Your Handy Companion to

DEVISING AND PHYSICAL THEATRE

INCLUDING FIVE PLAYS TO PLAY WITH

2ND EDITION

PILAR ORTI

WITH PHILLIP JOHNSON, RICHARD MANN AND MARK REID

Your Handy Companion to Devising and Physical Theatre including Five Plays to Play With
Pilar Orti is hereby identified as the author of this text in accordance with section 77 of the Copyright, Designs and Patents Act 1988 ALL RIGHTS RESERVED.
First published in 2011 by Paperplay
This second edition published in 2014 by Paperplay.

ISBN 9781291718850

Your Handy Companion to Devising and Physical Theatre
© Pilar Orti 2011, 2014
So You Want to be a Physical Theatre Performer © Pilar Orti 2005
Up the Hill Backwards © Richard Mann 2003
Cairo 1948 © Phillip Johnson and Pilar Orti 2004
Legacy of Blood © Mark Reid 2007
Softly, Softly © Pilar Orti 2008
The Can Scene © Phillip Johnson 1999

Cover by Manuel J Barrio.

ALL RIGHTS RESERVED.
No part of this work covered by the copyright heron may be reproduced or used in any form or by any means – graphic, electronic or mechanical, including photocopying, recording, taping, web distribution or information storage and retrieval systems – without the written permission of the author.
However, if you are a student or teacher and wish to use this material in class, please feel free to do so.
Published by Paperplay.

"Error is not just acceptable, it is necessary for the continuation of life, provided it is not too great. A large error is a catastrophe, a small error is essential for enhancing existence. Without error, there is no movement. Death follows."

— Jacques Lecoq, 'The Moving Body'

Contents

Introduction to the Second Edition ... 1
Introduction ... 3
PART 1 CREATING PHYSICAL THEATRE .. 9
CHAPTER 1 STRUCTURING THE DEVISING PROCESS ... 11
CHAPTER 2 BUILDING THE ENSEMBLE 19
CHAPTER 3 DEVISING FROM A STIMULUS 27
CHAPTER 4 CREATING A CHARACTER 33
CHAPTER 5 CREATING TEXT .. 45
CHAPTER 6 STYLISING YOUR WORK 51
CHAPTER 7 USING MUSIC .. 57
CHAPTER 8 TOWARDS COMPLETION 61
PART 2 WORKING WITH MASKS ... 71
CHAPTER 9 INTRODUCTION TO MASK WORK 73
CHAPTER 10 WORKING WITH MASKS 81
PART 3 FIVE PLAYS TO PLAY WITH ... 89
SO YOU WANT TO BE A PHYSICAL THEATRE PERFORMER? ... 91
UP THE HILL BACKWARDS by Richard Mann 101
CAIRO 1948 by Phillip Johnson and Pilar Orti 111
LEGACY IN BLOOD by Mark Reid ... 117
SOFTLY, SOFTLY by Pilar Orti ... 125
FURTHER READING ... 141
ACKNOWLEDGEMENTS .. 143
ABOUT THE AUTHOR .. 145

Introduction to the Second Edition

By the Spring of 2011, I had stopped calling myself a "theatre practitioner". I had left my days as director, actor and workshop leader behind to set up a management consultancy. However, I still had many notes, handouts and scribbles I had created over more than ten years with Forbidden Theatre Company, stored away in my computer.

When Amazon opened its Kindle platform, I saw the opportunity to release my notes into the world, in the hope that they would be of use to other teachers using physical theatre in the Drama classroom. So I gathered my notes, looked for some short scripts and created this handy companion.

Most theatre books have been written with teachers and practitioners in mind. They are thorough in their approach and they're also very long. When I put this book together I envisaged a student looking through it and using every single page during their devising process. I also imagined a teacher having to teach a unit on Devising for the first time reading the book, making notes and creating from them the lesson plans for half a term.

The book made it on to the reading lists of a couple of schools and an examination board. I barely marketed the book and yet it seemed to sell: I was obviously meeting the need for a concise book about creating physical theatre in the classroom.

So here is the second edition of 'Your Handy Companion to Devising and Physical Theatre'. I've restructured it, added some chapters (mainly on Devising from a Stimulus, Getting Feedback and Recording Your Process) and included some notes to help you use

five plays to explore different aspects of physical theatre. Do visit the online site www.devisingandphysicaltheatre.com when you get the chance and let me know how you get on.

Creating theatre together is a celebration of all the good things we do together as humans. Enjoy!

Pilar Orti
April 2014

Introduction

More and more young people are studying physical theatre as part of their Drama programmes. Most qualifications (be they Drama, Theatre Studies, Performing Arts etc.) require students to devise their own work. This is an opportunity to encourage them to be as theatrical as possible in their approach and steer them away from naturalism. Sometimes this will be difficult as students' performance style is mainly influenced by television. Furthermore, most young people will have seen little theatre where the acting doesn't resemble what you see on the screen, like in a traditional musical theatre show or a straight play.

I am of course making a broad generalisation but my experience of working with young people in the UK is that most under-16s will have had little exposure to highly theatrical work. Once students get older, teachers find it easier to organise trips to see more adventurous work and the students themselves begin to seek more challenging experiences as an audience.

So it can be difficult to encourage drama students to use physical theatre in their own work, when they might not have come across the art form before or when they do not consider it to be "proper acting". However, physical theatre allows your action to be filmic and it can take place in different locations, as the need for realistic sets is removed. Through the use of music and movement, the audience's experience can be made memorable, regardless of the length or complexity of the piece. Finally, most physical theatre requires an Ensemble, a group of performers who all contribute equally to the piece: there is no need for "main parts".

I've written this book to support those drama teachers who, with little experience of physical theatre themselves, have a genuine interest in the style and are keen to enthuse their students to use it in their work.

At the same time, I hope this book will prove valuable to those students who are already passionate about the subject and are keen to bring the style into their own work. I can safely say that in every group of drama students, there is always one who will go beyond the call of duty, driven by a genuine interest in all kinds of theatre and a passion to contribute to the art form. If you are this student, this book is for you.

Why Use Physical Theatre?

Our imaginations are boundless. Our lives are surrounded by stories of all kinds: urban myths, fairy tales, stories which are so rooted in real life that we mistake them for the truth. We explain the world around us through myths and stories, even through fables whose characters are not human.

As audiences, we enjoy stretching our imaginations. Therefore, when creating a piece of theatre, we can allow our imaginations to run free. We do not need to limit our situations to those based in reality: our characters can travel across rivers, they can fly or even exist in dreams and other surreal places. As humans we crave stories that will take us away from our ordinary world – that is why, despite the birth of film and television, theatre still has an audience today.

Whatever the stimulus or theme of a devised piece there is a need to ensure that the audience is taken on a journey. There might be elements of the story that seem difficult to communicate to an audience because it is difficult to act out their "reality". However, physical theatre can help to communicate the most fantastical or abstract concepts.

When using physical theatre we can:

- Depict fantastical physical journeys. For example, by creating the illusion of travelling through the air (without literally being flown through the space with a rope),

- Create surreal environments (such as somebody's mind),

- Develop characters from another world (such as those that are half human and half animal or grotesque villagers),

- Have flexible, easy to use sets – created by the performers as they become walls, rivers, furniture, etc.

Through believing fully in what you're doing and committing to the piece, you will carry the audience with you.

'Physical theatre' is a broad term and means different things to different people. You will find physical theatre pieces which have very little speech and have been devised in the rehearsal room or solo clowning pieces, or even adaptations of Shakespeare where only sections of the original text have been used. So your ensemble will need to find a style within a style. Here are some suggestions.

- If the intention is to convey emotion, the movement used can be choreographed, almost dance-like. In this way you can create abstract sequences intended to make the audience feel in a certain way.

- If you're using physical theatre to create a human set, your movement (or stillness) will need to be more literal. For example, to create a wall you'll use rigidity, or a crumbling movement if it is smashed. If you are depicting furniture, the performers will have to look like the real thing as much as possible.

- If the main aim is for the audience to fully understand the story, then physical theatre can be used to create a range of distinct characters, while keeping their actions realistic. Dialogue and narration can help to make the story clear.

The Ensemble

If there is one thing that all physical theatre practitioners will agree on is that we pride ourselves in creating ensemble pieces, where ALL performers are vital to the piece. Ensemble members work well together, feeding off each other during the creation process, listening with their ears and bodies, in tune with what they are all doing, all the time. When an ensemble is working well together, the audience FEELS the performers' joy in collaborating and this in turn heightens the audience's experience.

Working well as an ensemble does not necessarily mean that everyone gets on incredibly well all the time and that they are all great friends. It means people respect each other, share a common theatrical language and believe in what they are creating together. It is very important therefore that performers warm up together before rehearsals, carry out games and exercises to increase awareness of each other and spend as much time as possible trying out ideas in the space. Only in this way will they really understand how they operate individually and as a group.

It's worth remembering that the ensemble is made up of individuals and as such, everyone needs to take responsibility for their role in the creative process. Everyone works in different ways. Understanding how this enriches the piece will make the work even better. On a practical level, the ensemble needs to take care of the whole piece while the individual is responsible for developing his/her own character/s and bringing emotional truth to them. Although you might have some great ideas about how others' characters should be developed it is important that each performer explores their own ideas

first, as long as they are within the constraints of the piece and story. This will hopefully remind the more vocal students that everyone needs to take ownership of the piece.

Using this Handy Companion

This is by no means the authoritative guide to physical theatre or a thick volume of exercises (I have included a list of books at the end that will fulfill that function). It is a reminder of the ways in which physical theatre can be used to nurture the imagination and sense of collaboration in the classroom.

It's a guide to devising for students who have to create, rehearse and perform a piece together as part of a post-16 qualification, maybe for the first time. I hope it will also be a book that teachers can use to help their students go through the process without holding their hands.

In this second edition, I have gathered all the chapters containing exercises and advice on the devising process and put them together to form Part 1. CREATING PHYSICAL THEATRE.

This part begins with a suggested structure for the devising process for those students who need to create a piece for their assessment. This is followed by a small number of exercises to help with building the ensemble, creating a character and story and using theatrical devices.

As a teacher, you can also use the exercises on Creating a Character with your students outside of the Devising unit. As well as giving them an insight into how to create a character physically, you can also use them to raise their physical and emotional self-awareness, debriefing each exercise by asking questions like "How did that make you feel?", "What movement was easier/more difficult to do?" etc.

In Part 2, I introduce masks, for the more adventurous students or for those teachers who know they can push their students a bit further. For students, this part might allow them to create a large number of characters if their piece requires it. For teachers, using masks can help to illustrate focus, simplicity of movement and honesty in performance.

Part 3. FIVE PLAYS TO PLAY WITH uses five short texts to help the students explore different aspects of physical theatre within the structure of a script. The pieces were created by members of Forbidden Theatre Company's ensemble and presented during their Freestyle Performances. Some of the pieces will seem more polished than others but all of them illustrate how working in a stylised way can take the audience to a different world. Each script has some notes on how to use the text in the classroom to illustrate a particular aspect of physical theatre.

PART 1

CREATING PHYSICAL THEATRE

"I often tell actors that imagination is in the body: rather than being limited to a space in the brain, it lies in the movements of fingers and toes, in the contraction and relaxation of muscles. In improvisation, imagination is the response of the body to space, time, music and human dynamic that fuels the thinking brain, not the other way around."

Christian Darley, 'The Space to Move'.

CHAPTER 1

STRUCTURING THE DEVISING PROCESS

Creating a new piece will have its ups and downs. Some days you will create enormous amounts of material worth keeping, while other days everything will seem useless. Don't give up and don't be discouraged as this is all part of the creative process. When we create material that doesn't seem to work, we come closer to finding out where the piece is going. Sometimes it's just as important to discover what doesn't work as it is to create material that you can keep.

Usually students will have a long time during which to develop a piece (usually in short, sporadic lessons over 10 weeks). This is good news: it means you can experiment with ideas, dedicate sessions to developing character, incorporate the research gradually into the piece... you name it. But in order to keep the process fluid and give yourselves room to experiment and play, you need to be extremely well organised.

The first thing you will need to do is give yourselves some deadlines for completing the practical aspects of devising, such as the

costume and set designs and a written script for the sound and light operator. Once you've set these deadlines, stick to them – after investing all your creativity in the piece, you don't want the practicalities of theatre production to get in the way of your greatest enjoyment: the performance.

Below is a suggested timeline for the devising process. Different groups work at different speeds. Depending on the stimulus, you might need to allocate more time to some sections than I suggest here. In any case, use your time together productively. It's no use allocating a lesson to character development where everyone sits down and writes their character profile individually, when this could be done at home.

Your time together as an ensemble is incredibly valuable and limited. Similarly, you should use your contact time with your teachers and other groups wisely. If you show a teacher or your peers a section of the work during one lesson, make sure the next time you ask them to watch your piece you have developed that section further.

If you need a script for your lights and sound operator but there is little or no dialogue, describe what is happening on stage and how the plot is advancing. (For an example of this, read 'Up the Hill Backwards', in the last part of this book.) If there are specific visual moments to act as cues for lights and/or sound, describe them in detail in your script.

The Creative Process

You can think of the process of theatre-making as similar to that of writing a book. Writers don't write their final draft in one go. First, they let their imagination and talent run free by just sitting down and creating as much material as possible. If they need to do any research, they might do it before they sit down to write or they might

combine it with their writing periods. Writers don't write their final draft as soon as they start working on a book, so don't expect to write your script in one go. During this Experimentation stage, your time together is limited, so do as much research as you can in your own individual time and use the time together to share your findings. This might also be the time when you improvise to give you ideas for your dialogue and other text.

Once a writer has laid down their first draft, they start to revise and structure the book. A lot of the material will be thrown away and they will identify the places where they need to create new material. This is your Creation stage, where you start to build your characters, decide on the style of the piece, lay down a structure and begin to think about your design element, especially your music if you're using any. During this time you should start putting a script together. However, unlike writers who spend most of their time sitting down as they write their book, you should be creating material in the space, through improvisations, and resisting the temptation of sitting down to try to write your play.

The third stage a writer goes through is a long and tedious one. He/she starts to refine their writing (usually with an editor, an "outside eye") by going over the manuscript again and again, looking for grammar and spelling errors and cutting or changing the bits that don't seem to fit. This is your Rehearsal period. Some people find it difficult or boring to rehearse over and over again, but your focus should be on refining and building on the framework you've got, not on repeating. This is the time when you have to develop your own character and make sure you understand their world, as well as nailing down those movement sequences that involve being in tune with the rest of the ensemble.

Having given you these very distinct stages for devising a piece, I'll now share with you a secret: it's never this simple, it's always much messier and chaotic. However, if you keep this structure in mind, you'll be able to give yourself some breathing space at the beginning of the

process while having a good idea of when you should have a pretty definite version of your script.

Work Out a Schedule

You have a limited amount of time to create your piece so you will need to have a schedule. I suggest one here which assumes you have ten weeks from the moment you come together as a group to the day of your performance. You'll need to change this schedule to suit your own timeframe. This will be a good exercise to start getting your heads around what the whole process will involve. Come back to your schedule at the end of each week and change it as necessary, but keep coming back to it to make sure you know where you are (or where you need to be) in the devising process.

Week 1
Carry out research on your stimulus, if appropriate. Do as much research in your own time as you can during the first three weeks of the process. This is the time when you are likely to be experimenting and therefore you don't need to do much work on the piece itself in between rehearsals, such as learning lines. Make sure you allocate time to sharing your findings. Also, don't forget to look into which theatre practitioners are likely to influence you. You will need to research their work.

Decide on the performance style you will use. Start building the ensemble. Discuss the creating and rehearsal process.

If you need to keep a record of your devising process for your qualification, make sure you start writing during the first four weeks. This is when you will be experimenting and jotting down your thoughts will help you to reflect on the process and might even help you to

move forwards. *(To help you with this, have a look at Chapter 8. Towards Completion.)*

Use Chapter 3 to help you build your ensemble and Chapter 4 to help you work from your stimulus.

Week 2
Share your research. Decide on where the piece is going. Maybe outline the full story. Start improvising and creating material. Maybe a strong definition of characters.

Week 3
Continue improvising. Individual character work. Character profiles. Research on practitioners suited to the piece. *Use Chapter 5 to help you.*

Week 4
Set the story line and outline of the piece. Begin creating the piece. Set the order of scenes. What happens in each scene? Begin scripting. Start thinking of set and costumes.

Use Chapters 6, 7, 8 and 9.

Week 5
First drafts of set and costume designs. Continue creating the piece. More character development. Character-led improvisations which will lead to development of plot. Go back to Chapter 5 to help you define your characters.

Week 6
Begin rehearsals. Continue creating.

Week 7

Final set and costume designs. Purchase or identify set and costume elements. Continue rehearsing and refining. Ask people to be your "outside eye". *Use Chapter 8 to help you to use audience feedback.*

Week 8

Rehearsals. Define scene changes (if applicable).

Week 9

By now you should have the final version of your script. Run-throughs. More rehearsals.

Week 10

Tech Rehearsal. Dress Rehearsal (x2 if possible) Performance!

Once you have created a schedule, revise it at the end of each week. For example, you might come up with a wonderful storyline on day 2 of Week 1. Then you can start detailed character work earlier on and give yourselves more rehearsal time. Devising is not only group specific, but project specific too and the process constantly changes.

At the end of Week 1, you should ask yourselves how you will carry out the creation and devising process as a group. Will each member be responsible for a session? Do you want a teacher to run a session on Character Development so that all group members can work on character at the same time? Who will be running the warm ups for each session? For some sessions you will need longer warm ups than others, but you should always do something together, even if it is a quick game of tag. (For more on why you should play together, see Chapter 2.)

Just as it's essential to take part in an exercise together at the beginning of the session, it's vital to wrap up the session together too. Five minutes at the end of each session to reflect on what has (or hasn't) been achieved are very useful, as is making sure that

everyone agrees on what the next steps of the process are and what shape the next session will take.

CHAPTER 2

BUILDING THE ENSEMBLE

Group Preparation

As with all drama workshops or rehearsals, it's essential to warm-up together at the start of each session, to get your bodies and minds ready to work. The importance of warming up together through working on the body individually and playing games, cannot be emphasised enough. Its benefits go way beyond "getting ready". Here are just some of the reasons why warming up together is essential – some of them apply especially to physical and mask work, but most of them are relevant to all actor training.

- Connecting the body and mind.
- Developing physical and emotional awareness.
- Training spontaneity and "being in the moment".
- Training taking risks.
- Training making mistakes together.
- Practising communicating in ways that don't include words – a look, a smile, a gasp, a laugh.
- Isolation of body parts.
- Warming up of joints.
- Spatial awareness.

- Practising humility, collaboration and commitment.

The list goes on.... For those students that don't like playing games because they want to get on with "proper acting", this list can provide a good reminder of how the exercises will help them to be better performers.

Don't feel like you need to vary your warm ups or play different games each time you begin a session. Practice makes perfect and some of these games become really interesting once everyone is skilled at playing them. This is also a very good way to train the craft of acting: an actor does not change character or script at every rehearsal; the skeleton of the work is the same and it's a skill to be able to explore different things within a tight framework. Once professional actors are in performance mode, they need to find the freshness of the first performance every single time, through their trained spontaneity.

Using Games

The potential of growing as performers through playing games is often overlooked. Games are more than "warm-ups". Of course they get us in the mood to work, they focus our attention and they are the fastest way of leaving everything else outside the Drama classroom door.

But the value of games doesn't end there. We cannot underestimate the value of practising "play". Practising taking risks, being in the moment, laughing at our failure when we get it wrong. The game provides a safe place where we can do all this.

Some games teach us even more than that. The clapping circle (and its sound-including variations like ZipZapBoing) reminds us that the whole of our body needs to be energised when we perform; that eye contact is vital for working with others; that sometimes we can go with the flow but others we need to make a big offer. Grandmother's

footsteps teaches us discipline and focus and using suspension. Even a simple game of tag can teach us physical self-awareness, spatial awareness and, why not, suspense.

So challenge yourselves. Debrief those games so that they become part of your learning, not just the first ten minutes of a session. I have included some things to think about so that whoever is leading the game can encourage the group to reflect on the experience through these questions. There are aspects of acting that can be trained by going through these exercises over and over again. Remember that what you'll end up creating will be called a Play.

Here are some of my favourite games. You probably recognise some of them from other drama lessons/workshops or from your childhood.

The Clapping Circle

This simple exercise gets the group focused, aware of each other and listening to the rhythm the group creates.

The performers form a standing circle. One person claps once towards the person on their right. They then clap to the person on their right, who claps to their neighbour. As the clap travels through the circle, the sound should be that of one person clapping. Once a rhythm has been established, the performers can start playing with the action, reversing the direction of the clap or passing it across the circle.

It's important that you are centered, ready to move, standing with your legs at least hip-width apart, using your whole body when passing the sound. Think of the soles of your feet being connected to your hands by a diagonal line passing through your body. The impulse to send the sound through comes from your feet, not just your arms. Avoid just using your upper body and leaving your lower half "dead".

Eye contact with the person you're sending the sound to is of vital importance.

The clapping circle also teaches us to listen out for sound patterns, to observe abstract movement and to analyse what keeps us engaged in a game while we observe others play it. It also teaches stamina: how long can you go on playing the game before you get bored? How do you stay engaged in the game? It teaches self-awareness: When do you enjoy the game most? How does your body respond to playing it?

And then there are those questions that you can ask yourself if you're leading the session: how is the group feeling today? Are we clapping around the circle like mad? Are we nervous? Are we under-energised? Are we not making eye contact? And then you can guide the group through the game accordingly. If your energy is unfocused, all over the place, slow down the speed, even going into slow motion. If you're under-energised, find a steady rhythm and then speed it up.

Grandmother's Footsteps

This game wakes up the body and mind and, though competitive, encourages performers to work in physical closeness to each other sharing the same space.

One performer (the "grandmother") stands facing a wall. Everyone else stands behind him/her at the other side of the room. The object of the game is for the rest of the group to creep behind the grandmother and tap her on the back. The grandmother will turn every few seconds and when she does, everyone must freeze. If she sees anyone move in the slightest, they have to go back to where they started. Whoever taps Grandma on the back first wins and becomes the next grandmother.

Grandmother's footsteps is used widely to teach acting and physical theatre. The game has the added benefit that it lends itself well to observation. Half of the class can sit and watch the other half play. By watching the game, you can analyse what makes a good piece of drama and what is interesting about watching actors:

enjoyment, commitment, the need to take risks, the need to play within the rules. This game has all the ingredients of a good theatrical performance.

You can also learn about suspension through this game. When Grandma turns around, we don't just freeze: our bodies are suspended as we wait for Grandma to turn her back to us again. When we freeze as Grandmother turns, we don't stop: our emotion is in motion. Our brains are ticking away, making sure that every single element of our body is still, we are holding on to our energy, not letting it go... and we are oh-so-ready, because at any point, Grandma will turn round and then... we have to be ready to move!

The breath follows our actions: we hold our breath while we suspend and breathe out when we continue moving towards Grandma. Can we make the audience feel this? Can we affect their breathing by changing how we move? Suspension can be useful when choreographing sequences. Can abstract movement evoke emotion?

As an example, take the staging of a storm on a ship. The ensemble moves to one side of the stage and everyone suspends their bodies. Then they run back to the other side, where they... suspend... again... and then go running to the other side again. If you can achieve this choppy rhythm together, you're on your way to making your audience seasick.

Counting to Ten

This is an ideal exercise to focus the group's energy, to channel it into the space and get everyone listening to each other extremely carefully.

The group stand, or sit in a circle, with their eyes closed. The aim is to count to ten or a higher number (this number should be higher than the number of people taking part). The group must make sure everyone is ready to start the exercise and then someone at random

starts by saying "one". Someone else will then say "two" and so on. If two people say a number at the same time, the count must start again.

Name Tag

Tag games are good energisers. They encourage you to move spontaneously in the same space as your fellow performers, tuning into what's going on and training your peripheral vision. Remember to stay relaxed while you're playing. Check-in with yourself every now and then, give your shoulders a shake. (Were you breathing or holding your breath when you were running away?)

Name Tag is mainly a game of tag where you save yourself by calling out another person's name.

Someone is "it". When someone is about to be caught, they shout somebody else's name. That person then immediately becomes "it". If someone is actually caught, they are out.

Elves / Witches / Giants

Similar to the traditional "stone, paper, scissors".

The group decides on three physicalities for each of the three creatures at the beginning of the game. They then divide into two teams. In each team, performers decide what group of creatures they're going to be. Elves overpower giants, who overpower witches, who win over elves. The two groups then meet in the centre of the room (between their homes) forming two lines. At the count of three they physicalize their creatures, and those with greater powers have to chase the others, who can save themselves by running to their "home". If any of those with "greater powers" catch someone else, they will add them to their team. Decide for how long you will play the game, as it can go on forever. Sometimes the game comes to a natural end when everyone becomes part of just one team.

When playing this game, you need to pay attention to detail when changing your physicality. Think about using different height levels for the creatures. What do they do with their arms? Do they make a sound? What is it? This game is about having a bit of fun chasing each other and running around, but it also gets you to make some bold decisions on how you approach a character physically.

The Empty Chair

This game works best with at least seven people. You'll need the same number of chairs as people playing the game. Distribute the chairs evenly across the space. Everyone but one person, the Walker, sits on a chair. The empty chair must be at one end and the Walker starts the game at the other end.

The aim of the Walker is to sit on a chair. S/he will do this by walking towards it at an even, slow pace. Everyone else must prevent the Walker from sitting on the empty chair. You do this by leaving your chair and sitting on the empty chair. This leaves another chair empty. The Walker will then try to get to it but someone else from the group should go towards it and sit on it. Everyone but the Walker can move as fast as they want.

Note that once a member of the group lifts their bum from their own chair, they can't go back to it and so, they have to sit somewhere else. When the Walker finally sits on a chair, the game ends and whoever was left standing becomes the Walker.

Once you have played this game a few times and are familiar with the strategies that work, try to play the game in silence. Of course there will be some shouting and laughter but try to avoid communicating with words. This will help you to get used to reading what is happening in the space and communicating using your eyes.

Above all, avoid telling people what to do. If you see an empty chair and you know you'll never get there on time, of course point this out (or shout it out!). But avoid saying things like: "Fred, go and sit there!" The group needs to find a way of sharing responsibility. This is a good lesson to apply to the whole of the devising process: notice the

problems, point out the problems but don't always push through your own solution. If one or two people seem to be always looking out for the group and asking others to carry out their plans, the rest will lose interest and the piece will become one person's vision, not a collective one.

CHAPTER 3

DEVISING FROM A STIMULUS

In this chapter, I focus on devising from fairy tales, paintings and current affairs. They are the three most popular stimuli but even if you're using different ones, you can probably apply some of these suggestions to your own process.

Creating from Fairy Tales

Fairy tales are a wonderful stimulus to devise from: they have strong stories, well-defined characters and you can set them wherever and whenever you want. They are usually set in interesting locations that will give you a lot to play with: a forest, a castle, a hut, a cottage, a tower... all locations which you will not be able to create literally and so, you HAVE to use your imagination and stimulate the audience's to take them where you want to.

So, your first questions should be:
- When are we setting the piece?
- Where are we setting it?

Will you be telling the story linearly or will you start at the end? For example, your story could begin with a woman who obsessively cuts her hair. When somebody suggests that she try growing it, just to "see how it looks", she tells them the story of how she hates her long hair:

she grew up in a tower, enduring her mother climbing up her hair constantly. (In case you haven't guessed, I'm talking about Rapunzel.)

Working With More Than One Fairy Tale

If you are working on more than one fairy tale, just pick three. Three is a nice number to give you enough variety. See whether you can link them in some way: by theme, location or character. When Forbidden Theatre Company created 'Spell', the story began with the plot of 'The Frog Prince', where a prince was so annoying he was turned into a frog by a witch. The woman in question did not know that she was a witch. She only discovered her powers when her rage at the arrogant prince was transformed into magic. This was the first time that she realised she had magic powers. Once she became aware of this, she decided to use them for good. That is, until she had a bad experience: after helping the King and Queen to have a child by using a potion, they neglected to invite her to the child's birthday celebrations. It was then that she decided to use her powers in an evil way. This is the bit we borrowed from Sleeping Beauty.

In order to link a few fairy tales together, you will have to read plenty of them to spot the possible connections.

Don't just take the story you're all familiar with as your starting point. Look for poems, ballets, films, paintings and illustrations that have been inspired by the tales and all the different versions that have been created. They might highlight different aspects of the story, or even suggest a narrative you hadn't thought of before.

Split Personalities

Fairy tales are beautifully crafted stories. There will therefore be a moment in the hero/heroine's journey when they have to make a decision that moves the story along. What would have happened if they had made a different decision? If you are working on one tale, this can be the moment where you can change the story, by showing a different resolution or by presenting more than one alternative. (If you like the sound of this, watch the film 'Sliding Doors'.)

Use improvisation to try this out - it will be hard, as the well-known decision will be on everyone's mind, but it's worth seeing where your instinct takes you.

Create New Characters

Make the stories your own. Don't just create your characters around the obvious protagonists. What if someone had been observing how Rapunzel's hiar was being used as a climbing rope? This person could have an interesting story. Or how would the life of a Queen's servant change, when they disobeyed her orders by not killing a child? (As in Snow White.)

You can also create characters from inanimate objects that are part of the story. In 'Spell', for example, the spell book became the Witch's sidekick and was able to provide a different perspective and energy on stage.

Devising from a Painting

There are some questions you can ask yourself when working from a painting with people in it:

- Who are these people?
- What's their relationship?
- Why are they here?

In addition to this, ask yourself how they smell, what they smell around them, what can they can hear, who might be watching them?

If your painting doesn't have people in it, create a population yourselves. If people lived here, where would they live? In houses? Would they use what Nature offered to build their shelters?

Think beyond the painting and find out about the artist's world. Was this a typical painting? What did they usually paint about? What was happening around the time they painted this? What was

happening in their life and what was happening in the world? Was the painting inspired by a real person or real events?

What colours are in the painting? How do they make you feel? Can you incorporate them into your design? If these colours had opposites, what would they be?

What would be "the opposite" of this painting? What would be the alter ego of each character?

Remember that the painting is there just as a stimulus, something to trigger off an idea, a feeling, a theme... Don't talk for ages about it, it's tempting to spend a whole lesson in discussions about character, stories or theme. Discuss your ideas for about three minutes and then create three scenarios to work around. One might be an improvisation between the characters (don't worry about whether they talk or not, whether they use speech or movement to communicate with each other or the audience, at this point, you're just exploring); another might be about what could be happening around the corner from them, another could be a free improvisation around the emotions they might be feeling.

Current Affairs

Theatre is about people. And people are fascinating. Have you ever heard someone say, "You couldn't make it up!" after they read or heard about a real event?

You can find stories like these everywhere. Pick up a newspaper and you will read a story about a storm in the desert which revealed three shipwrecks that had been covered by sand for one or two centuries; or about a family who faked the disappearance of their daughter in order to get in the papers; or about a girl that was injected with glue in the brain after an operation. "Why would someone do that?" you'll ask. And that will be a great starting point.

Look out for "big stories" but also look for those that might be overlooked, the human interest stories. Those stories about ordinary people. What do they say about society today? Could they have happened at another point in time? If so, in what way would they have been different, if at all?

You can take one of the less featured people involved in the events and make up their story. Or you could show the story of the journalist and how they're affected by what they're reporting. Think beyond the story, beyond the news, beyond the headline.

CHAPTER 4

CREATING A CHARACTER

The following exercises can be used at different stages in the devising process to create characters, advance the plot or develop the characters.

You can create the physicality of a character right at the beginning, before you even have a character profile. Be bold in your choices: you will know when something doesn't work and when something feels right. And remember, you can always change your physicality as the piece and your character evolves.

Making some decisions about how your character moves will help you not to be self-conscious when you're improvising, as you will feel less like yourself. You can experiment with the different physicalities developed through these exercises and begin to build your character around them.

Interesting situations often arise out of conflict – this might be between two characters or the inner conflict a character might experience. You can develop your plot by placing your character in a scene and change his/her physicality halfway through. Just changing your physicality in one of the ways I suggest below might trigger an idea for something that happens to the character or within them. Instead of deciding what happens to the character before hand, you can see what your physicality suggests to you or those watching you.

You can also use these exercises after you have created a character profile and a character journey. If you have developed your character emotionally and through the plot first, these exercises can help you find a physicality that is different to your own. These techniques can help fuel your imagination by encouraging you to move and use the space around you in ways that are not familiar to you, creating a wide range of options for your character.

The Seven Levels of Tension

For the following exercise you will need to increase the tension in your muscles gradually. Make sure you move swiftly from one stage to the next and that you warm up before you start. Your warm-up should include relaxation and stretching exercises.

Start by lying on the floor. Feel your weight giving in to the floor. You are aiming for a state of complete physical relaxation. As if you'd been doing hours and hours of exercise and you had completely collapsed on the floor. This stage is:

Level 1: Collapse - no energy, heavy, every action is a massive effort.

Gradually begin to move your body. Start with a foot, or a finger, until you have slightly more tension in the body, just enough to get yourself up and have a relaxed walk around the room, maybe imagining it's a nice sunny day and you are walking in the park. You are now at the next state:

Level 2: Sunday afternoon - a 'cool' walk, very little energy is used for movement.

Now change your walk so that you reveal as little about your state of mind as possible. Make your pace even, arms swinging casually by your side, straight back, open chest, with no expression on your face. This is the most difficult state to achieve.

Level 3: Neutral - no emotion, gives nothing away.

Now pretend that during your walk, you remember you left the oven on. You begin turning back but decide that after all, you had switched it off. Then you think about it again and turn back. No, it's definitely off. No maybe it's on... etc. Each time you have a new thought, the body tries to move in a new direction, until your movement is jolty. The body now begins to have more tension than you are probably used to. This is

Level 4: Confused- Yes/No - the clown rhythm.

You finally decide that you did indeed leave the oven on and straightaway head home. You are in control, nothing is really going to happen but now that you have decided to go back home, you might as well get there as soon as you can. It is no surprise that this next level is called:

Level 5: Decide and Go – very direct, definite movements. Tension begins to rise in the body, but still controlled.

However as you walk towards your house, you remember that not only did you leave your oven on, but also the washing machine, and the video. Scared that there might be a power surge that will start a fire, you run back home in a state of:

Level 6: Panic – a high level of tension in the body now, the movement becomes very fast, in all directions.

The last state is rarely seen in real life. Imagine that the tension during the panic state builds up so much that eventually the muscles are all so tense that you freeze.

Level 7: Hypertension – there is so much tension in the body, that movement is impossible. This leads to Collapse.

Using the Seven Levels of Tension to develop plot.

To develop your story further, you can place your characters in situations and change their level of tension suddenly. For example, imagine your character is in level 2, very chilled out. We can place him/her in a familiar situation to them, enjoying sitting on a park bench, reading a newspaper, with another character. The level of tension of our chilled out friend suddenly changes to that of Level 6, panic. They've read something in the newspaper that has made them incredibly nervous, or maybe they've heard a series of strange sounds that brings back past unpleasant memories or maybe they've remembered they were angry at the other character for something. All this can be decided by the actor on their feet or they can play the scene and decide on the reason for the change of physicality later.

Playing with the levels of tension reminds us that a character's emotional state will affect the whole body, not just their face. If a character is nervous, the whole of their body is nervous. This does not need to result in overacting: sometimes the tension might be internal and it might be enough just to be aware of it without necessarily making it visible to an audience.

The Elements

This is a similar exercise to The Seven Levels of Tension. Make sure you move swiftly from one stage to the next and that you warm

up before you start. Your warm-up should include relaxation and stretching exercises.

Water

Starting from a neutral walk, imagine you come to the shore of the sea. Start going into the water, feeling it under the soles of your feet, then up your ankles, knees etc. Do this gradually, noticing how the movement of your limbs changes when they are under water. There is more resistance than when you walk through air. Carry on until the whole of your body seems immersed under water. Then reverse the process until you are back at neutral.

The movements of very watery characters are fluid and lacking in angles. Their walks are circular, moving in curves, not at sharp, straight angles. Water people are very calm and practical. (For positive qualities, think "stream"; for negative, think "floods".)

Air

Imagine your feet start to fill up with air, then your legs, hips etc until even your arms and head seem like they are floating. Your eyes too have air behind them. Try to have a conversation with others – you probably don't get beyond "Hi!". Once you've had enough of the airhead experience, reverse to neutral.

The limbs of airy characters are very light and their movements practically weightless. They are stuck in their own reality, and have their head (almost literally) in the clouds. (Positive: breeze; Negative: hurricane.)

Earth

Always keeping your back as straight at possible, begin to imagine that your feet are very heavy. And so are your legs. Although they are heavy, you can still lift them with no effort but you are very aware of your connection to the ground. Apply the same principle to the rest of the body. Your arms, they are heavy but you can move them, your gestures are probably well defined and direct. What's it like to shake other people's hands?

The movement of earthy characters is very solid and mostly performed in straight lines, as opposed to the more curved movements of the air/water characters. Their weight is directed downwards (towards the Earth) and steps tend to be grounded but not always heavy. These characters are also practical but can also be aggressive and confrontational. They will hold their ground. (Positive: solid soil; Negative: volcano.)

Fire

After having gone back to neutral, imagine that the ground begins to feel hot. The soles of your feet are burning and you try to reduce the amount of time they are in contact with the floor. The heat sensation starts going up through your legs, and your torso, your arms... There is even fire behind your eyes... Make sure you slowly bring this down, and bring yourself back to neutral.

The movements of fiery characters are very erratic. They follow a similar yes/no pattern to that of the clown and so they can seem nervous or insecure. On the other hand their movements are full of an energy which might be dangerous either because of its lack of direction and focus or because of its power. (Positive: warmth; Negative: fire out of control.)

Using The Elements to develop your character.

If you have already started to build your character, you can use The Elements to help you build their physicality. Your character might be quite dippy, in which case the physicality for AIR might be appropriate. There might be things that make them nervous, adding short bursts of fire to their physicality when this happens.

Depending on the style of your piece, you can use these physicalities to varying degrees. A piece with grotesque characters might take a character that moves through the space as WATER very well but if you are using this for more realistic characters they might just have the qualities of water. Their speech might be fluid, their walk purposeful but smooth and they might always remain calm in difficult situations.

Grotesque Characters

Your piece might benefit from Grotesque Characters. If you are telling a fantastic story, or have surreal sequences (like dreams) it might be worth exploring how to alter your physicality to create a character that is immediately recognised as out-of-this world.

You can combine the Seven Levels of Tension and the Elements to create odd characters. Or you can use just the Elements, but play with giving your upper half the physicality of one element and the lower half the physicality of another one. This can have very comic results.

You might also want to heighten the use of certain body parts. Make sure you move swiftly from one stage to the next and that you warm up before you start. Your warm-up should include relaxation and stretching exercises.

Explore one body part at a time:

- If you had big feet, how would you walk?
- If your knees directed your movement, how would you walk across the space?
- What would happen if your bum was the biggest part of your body?
- If it was your chest?
- What would happen if you had a stiff neck?
- And how would you move across the space if your head was your biggest body part?

Experiment with combining two or more of these heightened body parts. Try to perform every day actions like sitting down, lying down on the floor, putting on your clothes, reading a book, etc.

Finding a Voice

When finding a voice for your character avoid going straight into speech, play first with making sounds. This is especially relevant if your character is out-of-this world.

What sounds do they make when they finally sit down after a long day? What do they shout when they miss the bus? You might even try to have a conversation in a nonsensical language first (if you can't think of one, just say "willow willow") and then eventually go into speech. This will help you to focus on how your character communicates rather than on creating a dialogue.

- Does your character hesitate a lot?
- Do they usually speak fast, slow?
- Do they vary their pitch? Is it high? Low?

- What do they do with their hands when they speak? And with their eyes?
- Do they speak loudly or quietly? And does this vary depending on who they're with?

Character Journeys

If you are struggling to develop the plot of your piece but already have very strong characters, it might be worth looking at your characters' individual stories.

Individually, map out what happens to your character throughout the piece. What are they doing at the beginning of the piece, how do they feel? And how do they change throughout the piece? In what emotional state are they at the end?

Prepare a short piece to show the rest of the group (lasting no more than two minutes) which shows the character's journey: maybe through still images or by mixing narration with abstract images that show emotions.

This should highlight any gaps in the journey or any moments which are not clear. They might provide you with material to develop into one or more scenes or might even spark off ideas for a subplot.

Swapping Characters

Half way through the devising process, when you feel like you know your own characters inside out, when you are already familiar with the world you are creating, it might be worth taking the time to gain distance from your own contribution to the piece.

One way of doing this is by swapping characters. You can take scenes that have already been developed or allow yourselves to improvise new material while in another character's shoes.

When you are playing somebody else's character, try to find the essence of that character – avoid mimicking your fellow actor's performance, bring something new to the role.

Debriefing is very important after this exercise. Discuss whether you think there are elements in this new interpretation worth incorporating into your character and make sure you bring up anything that strikes you as very different from how you have been playing it. It might be that these differences are part of your fellow actor's interpretation but they could also be there because you are communicating something different from what you intend to portray.

Interactions

This exercise will help you to develop your characters further and begin to interact with other characters. You will need an "outside-eye" to run the exercise and a group of you should form an audience. The audience's role in this is essential, as they will be the ones using their imaginations to make connections between the characters.

In the performance area, set a chair or other object downstage left and downstage right. One chair will signify "very much" and the other one "not at all".

Have three or four characters on stage. The exercise leader will ask questions about the characters. For example, "How much does your character love money?" The performers will need to position themselves between the chairs, depending on whether they are closer to "very much" or "not at all".

How much do you love money?
How much do you like working?
How much do you enjoy being with other people?
How much do you like to party?
How much do you like your family?

The leaders should try to encourage awareness of the other characters by interacting with them:

"Hang on, you love money but you don't like working? Is that right? So what do you think about her – she really likes working..."

OR

"Have you noticed that you two are the only ones who like being with other people? Maybe you like each other? Have you met before?"

Following the exercise, those watching should comment on what they have seen: which characters seemed to like each other, which didn't, what kind of group were they. For example, maybe they all like to party in which case you might think about setting the scene in a town where they love rock-and-roll. Or maybe they all liked having a family, so you might think about grouping them into families, etc.

After you take part in the exercise, share any discoveries you've made while in the space and any observations you have about the group or the other characters. You can use some of these ideas to help develop your story.

- Where might these characters live? (e.g. a block of flats, the moon, the countryside...)
- Did you observe any "groups"? (e.g. thieves, children, a family, bankers...)
- When do you think these characters exist?

Character Backstory

This exercise will help you to create a character profile and backstory for the characters and begin to discover the world they inhabit.

Following the above exercises, the group should decide on where and when to set the story. If possible, (especially if there are more than 8 characters) identify two distinct groups, then decide on two locations or eras – this can help to give the piece an interesting form, for example modern characters waking up in the middle ages; city people travelling to exotic destinations etc.

Having decided on where to set the story, each performer should create a back-story for their character.

Name:
Year of Birth:
Place of Birth:
Age:
Current residence [town, city, place, type of "house"]:
Who do they live with, if anyone?
Are they in love?
What might a typical day be like for them?
Are they connected in any way to the other characters?
Have they ever met any of the other characters? When, where, what happened?

Create your character profile in your own time and use your sessions together to share your decisions or discoveries. See whether you can find any connections between the characters: any locations they might have in common, whether their values and morals clash etc. It's very likely that a lot of this backstory will change as you develop the piece. Don't be precious about it. Your backstory is something to help you create a world for your character but it's probably a decision you've made on your own. You need to adapt and develop your story in line with what the ensemble is creating.

CHAPTER 5

CREATING TEXT

Physical theatre seems at its best when it incorporates both movement and text. If you are using dialogue you'll need to decide whether you want it to match the style of the piece or whether you want it to be different (more on this later).

Using Poetic Text

A carefully choreographed, sensual movement sequence might be accompanied by poetic text to heighten the beauty of the scene. The language doesn't have to be elaborate and the vocabulary can be simple. Just playing with the rhythm of the speech can communicate a state of mind to the audience very quickly. For example, long sentences might communicate a lucid state of mind, while short statements might indicate agitation. (For fantastic examples of this, see the works of the language master, William Shakespeare.)

Here is an extract from 'Goddess', a piece created by Forbidden Theatre Company. This is the first dream the Woman has, where she explores the idea of forbidden love through the story of Psyche and Eros, love between a mortal and a god. Here, Psyche is waiting to be sacrificed to a monster at the top of a mountain. Aphrodite, Goddess

of love, jealous of Psyche's beauty, has sent Eros to shoot his love-arrows at Psyche, to make her fall in love with the monster.

When Eros is about to shoot one of his arrows at Psyche, he trips and shoots himself, falling in love with her. He takes her away with him making sure that she doesn't actually see him, as he wants to keep his God identity hidden from her.

(EROS spots PSYCHE and gets ready to shoot his arrow. Unfortunately right at that moment he clumsily trips, shoots himself (in the foot) and falls in love with Psyche. Silence. EROS looks at PSYCHE, but she can't see him. EROS goes to Psyche and unseen by her lifts her off the ground, teaches her to fly (teaches her to love?))

PSYCHE
And then,
A breeze,
A breeze that far from hurting me begins to cradle me....
Then turns into....
A gust of wind, a gentle wind which lifts my feet off the ground
I surrender
A gentle wind.....

(Through the following dialogue, Psyche does not see Eros as he is standing behind her.)

PSYCHE
Who are you?

EROS
That is not for you to know.

PSYCHE
Soft breeze...
Do you love me?

EROS
More than you could imagine.

(He lifts her.)

PSYCHE
Where are you taking me?

EROS
To our home

(EROS takes PSYCHE away from the mountain, saving her from dropping several feet every time she feels unsafe in the air. She tries to hold onto him but slips away, the third time this happens, she is held by the BROTHER, who appears during a sharp intake of breath from all characters, including the WOMAN. The dream freezes, the woman is not just dreaming of love, she misses her brother's protection. Meanwhile EROS is holding the image of PSYCHE in his hands (she is still in the BROTHER's arms.))

PSYCHE
You cradle me,
Far from being scared I feel safe in your arms.
Do you love me?

EROS
More.... More than you can imagine.

PSYCHE
You have given me back my life. I must see who has saved me from....

EROS
No! You mustn't, you must never see who I am. We must love each other at night, in darkness....

(As the BROTHER passes PSYCHE to EROS.)

PSYCHE
A gust of wind,
A gentle wind which lifts me off the ground
I surrender,
A gentle wind.....

As you can see, the dialogue is kept to a minimum and is used to pass detailed information to the audience. For example, "Scared, I am left at the top of a mountain" immediately tells the audience where Psyche is. The performer can show by her movement that she is

somewhere that is making her uncomfortable, somewhere where she is cold, from where she can look down. The text helps her pass specific information on.

Similarly, a carefully choreographed section can depict flying without the performers lifting their feet off the ground. In 'Goddess', a sequence was created which gave the illusion of the upper body being lifted. The rest was done by the text: "A gentle wind which lifts my feet off the ground."

The whole sequence above is performed with the actor playing Eros remaining always behind Psyche. Through the dialogue we know that Eros is deliberately remaining out of Psych's sight.

"PSYCHE: Who are you?
EROS: That is not for you to know".

Stylising your Speech

If you want to move away from naturalistic text but you're not sure where to start, you can use "normal" improvisation to help you.

Play the scene in character and communicate vocally as much as you need to and in whatever way comes natural. Keep the scenes short and ask someone else from the group to watch and write down any important moments.

Improvise the scene again, making sure you have given the characters an ACTION to perform either related or unrelated to your piece. For example, they might be arranging a pile of books in alphabetical order. Carrying out a physical action will keep your conscious brain busy, allowing your creative side to work on using language.

Try not to answer any questions directly – for example,

A
Are you feeling all right?

B might answer, instead of "yes":
Is the sky blue today?

So, if you are using movement to tell your story you might consider finding a vocal language which will complement it. Or, if you want to create a comic or quirky effect you can have the characters use naturalistic dialogue in a scene as they carry out abstract movement.

Using a Narrator

There might be times when you want to use a narrator or narrators. For example:

- If the plot is complicated or you have a number of subplots which you want the audience to understand completely.

- If the location varies greatly from piece to piece. This might be more suited to fantastic stories where the action takes place in worlds difficult to depict. "After leaving her castle, the princess found a cave on the opposite shore of the river."

- If time passes in between scenes.

- And more obviously, if you have adapted a story-telling style for your piece.

There are many ways of using a narrator figure . The characters can narrate themselves (like in 'Cairo 1948', included in the last part of this book) or the performers can alternate between being their character/s and a narrator. Don't forget that narrator figures can also have distinct attitudes to the piece, to other characters and to the audience. There is no need for them to be neutral.

Mixing It Up

You can pick a style of dialogue to match the physical style of your piece or you can deliberately pick one to contrast it. You can achieve a surreal quality by mixing styles, but make sure this is deliberate and not just the result of laziness!

For example, you can have two people performing beautifully choreographed dance-like movement that shows how much they love each other. At the same time, they can be holding a conversation about a film they've recently seen together. In this way, the choreographed movement will become your subtext and the contrast in rhythm and style will be interesting to watch.

CHAPTER 6

STYLISING YOUR WORK

Using a Prop

One of the ways in which you can stylise a scene is by channeling communication between the characters through a prop. The best way of explaining how you can do this is through an example: 'The Can Scene', from Forbidden Theatre Company's devised show 'Flat One'. This is the first time we meet the characters so you don't need any background information, just as Steve and Ruth didn't have any information on their characters when they created it.

The scene begins with Steve sitting on a "sofa" (two chairs usually signify two chairs, but by magic three chairs become a sofa, or a bench). Ruth places a can of Coke in the middle of the room after she's finished drinking it. Steve removes it. Ruth puts it back. Steve crunches it and throws it away. Ruth tries to restore it to its original shape by blowing into it and puts it back in Steve's view. Steve starts laughing gently to himself – this whole situation is ridiculous. He is apparently trying to make up with Ruth. They start getting "physical" with each other and soon it looks like they are about to have sex on the floor. However this is just a clever maneuver by Steve to pick up the can from the floor and chuck it to one side. Ruth is about to give up on the whole can issue when she spots another can at the other

side of the room. But so does Steve. They both get ready to dash towards it – as in an Athletics race. They both GO! and Ruth picks up the can. With a victory smile on her face she holds up both cans. Steve looks at her and says "I'm leaving". Ruth is left to bring up two cans on her own.

The whole scene is performed without any words except for Steve's "I'm leaving", which makes the text even more powerful. All the characters' frustrations are channeled through the can of Coke – however, the audience understands that the scene is about the breakdown of a relationship as each character tries to get their own way.

The main story is pretty clear: a couple argues, they both try to win the argument until one of them can't take it any more and leaves. But the absence of text means that each member of the audience will interpret the subtleties of the scene in different ways. This is one of the joys of physical theatre.

Slow Motion

Slow motion is very useful to highlight moments of importance, to introduce comedy into the piece and to show surreal moments. Here are some things to consider when using slow motion:

- Make sure everyone is moving at the same pace! (Unless for comic effect you want everyone to move at different speeds.)

- Make sure ALL your body parts are moving slowly – you need to dissect your natural movement and then repeat it controlling every single action.

- What is your face doing? Your eye movements should also be slow.

- At what EXACT moment do you all go into slow motion? And when do you change back to normal speed? Don't leave this to chance, set a cue. Also remember there needs to be a change in the body, like a jolt, at the instant the slow motion kicks in.

Stylising an Emotion

Sometimes you might want to use elements of physical theatre in a piece which is mainly realistic, for example to show what's going on in someone's head or to slow down a moment when someone receives a piece of bad news. In these cases, you can stylise the emotion. Here's a way of doing this organically.

Improvise the moment you want to stylise as a one-minute naturalistic piece. This will probably be a moment central to a character's journey or to the plot. Once you have done this, set it. Find the exact moment you want to stylise. Usually this will be a change in emotion, so identify the precise moment during which this occurs. For example, perform the piece again and monitor what your body does during that change in emotion. Be specific. Avoid generalisations like: "I am quite relaxed and then I get tense". How can we see you're relaxed? What part of your body gets tense? What are your hands doing? What about your chest? Your eyes? Your toes?

Share these physical changes with the other people in the group. When you explain things to other people, you force yourself to be clear and often come up with things you hadn't thought of on your own.

Once you have done this, run the piece again, but this time exaggerate the movements during the moment of stylisation. For example, a small twitch of the forehead will lead to a large frown. Or a small exhalation of breath will turn into a deep sigh. Increase the actions gradually, running the piece over and over again.

As with slow motion, you might want to mark the point at which the stylisation occurs. This shows the audience that something different is about to happen, or something of significance. It also "warns" them that you are about to do something theatrical.

If you follow this process, when you stylise an emotion you know it is coming from somewhere true to your character and that it's not just a clever bit of choreography. You have allowed the emotion to affect your body and then used these changes to shape your reactions into a more theatrical form.

Using Surrealism

If you need to create more material, go back to your script and see whether there is anything the characters say which the audience could be shown. Do the characters ever talk about their dreams? Their thoughts? What would be more fascinating than seeing the images formed in a character's mind?

A surreal image can help you make your piece more visually interesting and add depth to your piece. For example, there might be a character, Anna, who is happily telling her friend Susie about something that has happened to her. The audience however, can see Ana's alter ego (played by another performer) physicalising in slow motion a harrowing emotion. The alter ego character is obviously not real, but we use it to invite the audience into the character's mind and let them feel what the character feels.

Human Sets

Don't forget that as well as playing characters, you can play inanimate objects. For example, the ensemble can become the mountain that one of the characters needs to climb. Or each member

can become a piece of furniture in a house. Whatever you do, there are some things you might like to check out:

- Where is your focus? Are you all staring right ahead of you? Are you looking at the action? Or are you all looking in different directions? (If you are doing this last one, make sure you draw attention to it in some way or else it will look like you don't know what you're doing.)

- If movement is involved, are you all moving at the same speed?

- Are your bodies holding tension in the same places?

- If you are making sounds, are they synchronised? Or random? Or in a certain order? Does the rhythm at which you make the sounds change?

As an example, imagine that one of your characters is going on a journey. They have to cross a river, climb a mountain and make their way through a deep forest. The ensemble can help create all these scenarios, fluidly, one after another. But you must make sure that the transitions from one "place" to another are given plenty of attention. This can be very theatrical and you can really wow your audience.

The Chorus

The chorus is a homogenous group of actors who comment on an action. In Greek theatre, they helped to move the action forwards through narration.

A modern chorus can give your piece a surreal quality. It's quite unusual to see a group of people moving together as one entity – think about them moving like a shawl of fish. You can move across the

stage as a blob; you can speak together or finish each other's sentences. Your chorus can represent a group of people in the story: citizens watching the Mayor bribing someone or the souls of a murderer's victims watching her decide to take her own life. Although the members of a chorus move together and act as one, they can also have their own personalities. (For a parody of how the chorus can be used in a piece, see 'So You Want to be a Physical Theatre Performer?')

CHAPTER 7

USING MUSIC

Music can improve the quality of a piece in many ways. It can help INSPIRE you while you are creating scenes and developing characters and it can also help to move the audience and create atmosphere. As music speaks directly to the heart, it can move the audience without them having to analyse intellectually what you are trying to convey. There is no faster way to take an audience somewhere else than through the use of music.

Be very careful with the type of music you use: well-known tunes are fun and we all enjoy listening to them, but so will the audience. They probably have places or moments they associate with them and it might actually take them away from the piece rather than draw them further in. Film soundtracks are often suitable – again, try and find tracks that are not well known (unless of course you wish the audience to make an association between the film and your piece).

Look for soundtracks from foreign films; look for compilations of film composers or from contemporary composers such as Philip Glass, or Michael Nyman or Zbigniew Preisner. Or, if you're lucky enough to have a talented musician in your group, do create your own music.

Remember too that there are many other ways in which you can use your voice besides speaking. The most obvious way that comes to mind is singing, but there is always humming and making noises with your mouth. The sound of breath can also be powerful. Don't

forget about clicking fingers, clapping or stomping – creating rhythms and breaking them is also a way to add atmosphere to your piece.

Finding the Mood

There might be a scene that requires one or more characters to feel a strong emotion. It is sometimes difficult to portray this as a performer, especially if the emotion is an unpleasant one, like extreme anger or sorrow. In order to help you portray this, find a piece of music that evokes the emotion you are looking for. Then improvise the scene to the music – it might not involve text and the improvisation need not go on for long.

If you have already set the scene, then try it with music in the background. Take your time, do not rush the scene and make sure you keep the blocking and delivery of the lines spontaneous so that the music can affect you.

Then play the scene without the music. Again, keep it fluid – the music might have changed something in your original blocking and delivery of the text which is worth keeping. Remember to discuss the effect of the music afterwards with the group. If the music has evoked a strong feeling you might be tempted to immediately decide that the scene works best with music, but remember that an emotional moment can be incredibly potent if played in silence.

Action Against the Music

In the same way as you might want to use a piece of music to heighten the mood of a scene, you might want to use music to contrast it. This can sometimes have a comic effect, or even a harrowing one. There is something slightly disturbing for example

about watching someone crying their eyes out while REM's "Shiny Happy People" is playing.

If you are using heavily stylised or choreographed sequences to music, it might be worth experimenting with going against the tempo of the music. For example, a slow motion fight can go very well with an upbeat tune where you use fluid movements against a strong disco beat.

CHAPTER 8

TOWARDS COMPLETION

Obtaining Feedback

It's important to gain feedback from others once you've got most of your piece down, let's call it "work in progress". As a group, you are creating something that you will become very familiar with. During rehearsals you will discuss the plot, characters, themes and therefore understand the piece regardless of what the piece turns out to be. You want to make sure that the audience takes something away from it without having all the information that you have used during rehearsals.

The most important question you need to ask yourselves after presenting your work to an audience for the first time is:

"How was it for you?"

Very often you will know which bits worked and which didn't. You will be able to tell instantly how a scene went, whether the audience were with you or if they were restless; whether that comedy moment you worked on for ages made anyone laugh. You will know from their silences whether they were moved or just confused.

It's important that you obtain feedback from your audience in some shape or form but what's even more important is that, after talking to your audience, you and your fellow performers reflect on your own experience and their comments. Don't just present your show, get feedback and carry on. Let the feedback sink in, decide what you will take from it and what you will ditch (yes, of course it's ok to ignore some feedback) and then decide on how you will let it shape your piece.

You can use questionnaires to get audience feedback, but the most effective way of gauging what an audience has to say is by organising a discussion straight after they see your piece (a post-show discussion) or soon after. But also seek the opinion of those people who didn't say anything during the group discussion, as they might well have very interesting thoughts but didn't really feel like talking in front of everyone else.

Before You Begin...

Before you submit yourself to the interesting experience that is having people telling you what they think about your work (I use the word "interesting" because it describes a wide range of reactions: some people love having others telling them what they thought about their piece; others feel exposed; others just don't care), you need to know what you want feedback on.

- What sections are you least sure of?

- What do you want your audience to feel/think?

- Do you want them to understand every single element of your story? How important is narrative?

- Do you want them to feel empathy for all/some of the characters?

- Do you want to hear their different interpretations?

Once audiences start telling you what they think about your piece, the discussion can go on forever, so it's important to get the answers to your questions as soon as possible.

It's a good idea is to have one of you chair the discussion. You can start with "We've been thinking about the kind of things we're struggling with and we'd be especially interested in knowing what you think of x, y and z; although we really value anything else you have to say we might not have thought of."

Using Feedback

Try to understand where people are coming from when they give you their opinion. Are they trying to tell you about the piece they would have created or do they really understand how to help you create your own piece? Remember that, in the end, you are the ones who need to be completely happy with what you devise. Having said that, give full consideration to all comments as you might learn something from them just by reflecting on them.

Once audiences get going, they will provide you with contradictory comments. One person might say they really liked that the story was clear whereas others will say they would have liked a little bit of mystery to make them think harder. And if your discussion goes well, you will hear one person say, "I wasn't sure about the last scene" followed by someone else saying "Oh, that was my favourite bit!". So be prepared for this.

Listen to what makes sense to you as well as to those comments that take you completely by surprise. Above all, listen for common themes or recurring comments. If many people are agreeing on the fact that your character's reaction came out of nowhere, there's probably something that needs to be added early on in the piece. Or if nobody seems to be moved by the last scene, when you think it's the most poignant bit in the piece, then you'll need to address this.

Take notes. Don't rely on memory to remember all the feedback. There will be things that slip your mind. Get a pen and paper out and scribble down what people are saying. If you're getting feedback from your classmates or people you know, initial who says what, in case you need clarification later. If someone says something of special interest, approach them later about it to get further thoughts.

Although I'm not a great fan of questionnaires, they do give a voice to every single member of the audience. They also allow you to look at what people have to say whenever you feel ready, and not just straight after the performance, when you're likely to be tired or buzzing and not taking everything in. So do give some thought about whether you want to create some questionnaires for your audience. A good question to ask is always: "How would you describe this piece to a friend?"

Obtaining audience feedback during the creation of your piece is essential. It will accelerate your devising process. In addition to evaluating what you already have, there is nothing like performing in front of an audience to make you work extra hard.

Keeping a Record of your Process

If you're studying physical theatre or devising as part of a post-16 course, you probably need to keep a written record of your process.

Don't worry too much about your style of writing and especially, don't worry about sounding like you know what you're doing all the time. On the contrary, there should be times when you don't know what you're doing, where you feel like nothing is working and when you make mistakes. This is part of the process. Embrace it, it will give you plenty of material for your notes.

Your log should be a place where you evaluate your own contribution to the process, where you reflect on the material you're creating and where you talk about how each session moved the piece forwards. It might seem obvious, but a comment such as "the piece is

going really well" shows little about your ability to critically reflect on the process. However a comment like "The piece now has a structure: the story seems to flow well from beginning to end and it looks like each scene has the potential to really entertain the audience. I suppose the next step is to make sure we move from scene to scene in a fluid way."

On a similar note, if things are not going well, you need to analyse why and suggest a way forwards. "The rehearsal was a disaster" is not that insightful on its own, but if you follow it with "Gabrielle and I haven't really worked on our relationship that much and staging-wise, we're all over the place. I'm going to suggest that Gabrielle and I do a couple of improvisations about what happened before our scene, to get a feel of how the characters interacted before the time when we're setting the piece. I think it might also be a good idea to draw the house in which we're setting the play, to make sure we all know what is indoors and outdoors on stage, as we don't really have a set."

To give you some ideas of the kinds of things you can talk about, I am including here some notes from our production of 'Goddess' talking about the different challenges faced by the individual actors when creating the piece. They're written in the third person but they should give you a good idea of how you can talk about your process, how you can show that you have done your research and to describe how you built your character. If you have any questions about the context of these lines, drop me a comment via www.devisingandphysicaltheatre.com

Goddess: the Performers Speak

Alex – Brother

Alex's professional experience has been mainly in television and he is not used to working in a highly physical style, where the physical language comes before the word. To develop the piece we sometimes used free movement improvisation during which it is important to disengage the conscious mind in order to allow the body to feel what it needs to do. This is a very difficult task – you need to be able to express emotion through every part of your body: vary the quality of the movement, its rhythm to convey what your character is feeling, without resorting to words which prove so useful in everyday life.

A particularly tricky bit for both Alex and Pilar was acting out the children in the Prologue. Although in the tape we hear them as children, on stage they maintained the children's physicality but retained adult voices. This was done for three reasons. We seem to accept children's physicalities on stage but as soon as a "voice" is put on, it destroys the magic; the contrast between an adult voice and the children's physicality gave the memory a surreal quality, reminding the audience that it was happening in the Woman's mind; maybe the Woman remembered the Brother always with his adult voice.

Alex's character, the Brother, is the most difficult character to play in the piece, as there is very little information about him in the script. Indeed, many of the questions about him, why he kills himself (indeed, if he really did kill himself) have been left open. This information is only fed to the audience through clues and it is up to them to gather them together and draw their own conclusions. When we talked to audience members, some thought that he had killed himself because of his incestuous feelings towards his sister, others thought he'd died

in a suicide pact with his lover. In any case, the Brother never appears in real life – very much like the Myth characters, he is only in the Woman's mind. But whereas the myth characters have their own stories, the Brother is only part of what the Woman feels.

Added to the psychology of the character, Alex also had to find a way for the Brother to move. How does a dead person move? How does a dead person in the mind of his sister move? What seemed to work best were continuous, fluid movements as these are rarely seen in every day life.

However, for an actor to be able to play what is essentially a ghost, they must understand the character as an entity in itself. Why does he appear at certain points in the Woman's dreams, what triggers her to think about him? For example, it is obvious that he appears during Narcissus' death because she is disturbed by the possibility of him having killed himself.

The Brother's last scene is also difficult to play. Is this HIS absolution too? Has he been in purgatory all this time? Will his soul now be able to rest? He seems a lost soul when he is about to go into the river – but emerges clearly as the brother. Alex also had to decide whether the masked character he played in the Underworld was indeed linked to the Brother.

Steve – Eros, Narcissus, Hades

In order to play the different Gods, Steve researched other Greek myths to find out who they were and what part they played in Greek mythology – for example, Eros was one of the First Gods. Then he developed different physicalities for the three characters: Eros jolty and nervous, Narcissus grounded and confident and Hades developed an unnatural walk and a hunched shoulder turning him into the most grotesque creature of the three. And following the definition of their physicalities, Steve developed different vocal qualities for Eros

and Narcissus. Indeed, Hades never speaks — which is handy because how do you find a voice for the Lord of the Underworld?

The way in which we developed the myth sequences — developing the movement through which to tell the stories and convey emotions — also posed a challenge. We developed the physical "text" before the character. Therefore having then worked out the physicalities for the characters, Steve had to alter slightly the choreography. It's like approaching a text for the first time — to deliver it in your own voice might seem straight forward, but to adapt it to suit your character's speech takes time.

What Steve found most difficult to get to grips with was how to use the text in the first person to create a character which is coming out of the mind of a woman, a character which is almost narrating someone else's story. Like Alex, he had to find the truth for his own characters and work from there.

Just like an actor goes over their lines again and again to memorise them, to learn a physical sequence it must be performed again and again. One of the challenges that Steve faced when working in this way is allowing the body to remember the movement without the brain getting in the way. This means that the body needs to repeat the movement a great number of times, so that the actor doesn't have to think about the choreography — very much like a dancer does.

Ruth – Psyche, Echo, Persephone

In a similar way to Steve, Ruth's main challenge was finding the different energies for her three characters. Unlike Steve, Ruth identified different psychological qualities to help her differentiate her characters — this made sense as it allowed for our theory of projection to develop (following from Jeung's theory that all characters in our dreams are a projection of a side of ourselves), making each character a different side of the woman's emotional make up.

As well as defining the individual characters, Ruth looked for the different levels inherent in the piece: the story-telling moments when clarity of the plot should come first; when emotion was the main element to be transmitted to the audience; finding moments of lightness to avoid the piece becoming "heavy". She felt a tendency to make the piece intense all the time due to the nature of its themes and had to remind herself that the lighter moments were not only as important, but essential for the piece to be enjoyable.

Being on stage for practically most of the piece reminded Ruth of all the qualities an actor needs in order to perform to the full. She found herself never being able to just "mark" what she was doing and needing 100% energy every time she went over a sequence. She was reminded of how physically fit you need to be, how the body needs to be trained to remember the movement sequences and of course, how the speech apparatus needs to be ready to serve the text. Plus, the characters need to be developed, you need to leave room for exploration and it's essential to be constantly aware of others to serve this ensemble-led piece.

PART 2
WORKING WITH MASKS

"Whatever its dramatic style, all theatre profits from the experience an actor gains through masked performance. This is an example of teaching which does not operate directly, but through a ricochet effect."

Jacques Lecoq, 'The Moving Body'.

CHAPTER 9

INTRODUCTION TO MASK WORK

Masks can prove a useful teaching tool and working with them can be liberating for the student, which is why I have included this short section in this book. For more on Mask work, including how to make masks, I recommend Toby Wilsher's 'The Mask Handbook'.

The Power of the Mask

In a world where the Internet rules, where video is available on the phones we carry with us and where we can have the most adventurous experiences at the click of a games console button, why do people continue to make and watch theatre?

A trip to the theatre is a journey into another world: a world of ideas, a world of emotions, a world of magic... Theatre presents a condensed human experience. A good theatre experience will trigger your emotions a few times and leave you feeling like you have just been part of someone else's life.

Whereas television transports us somewhere else by showing us a familiar reality, theatre creates its own reality and seduces us into accepting it. Physical theatre, visual theatre, total theatre, name it

what you will, captures our imagination at different levels and engages us by applying varying doses of surrealism. (It is interesting to note how surrealism has also popped into mainstream television in the past decades e.g. Ally McBeal, Six Feet Under, My Mad Fat Diary, How I Met Your Mother, etc.)

When a mask appears on stage, you know you're in a different world. The creature in front of you is not quite human, but is inhabiting your world. Its face is still and yet full of expression. How can this be?

Your brain picks up clues from the performer's body, without your conscious mind even being aware of it. Your mind is working in a different way – making links that make you see something that is not really there: the mask smiled... well, you think you saw the mask smile. What you did was register the physical stance and movements of a smiling character, which made you think you saw the mask smile. As an audience you have no choice: you either engage with this type of theatre or you miss out completely on what's happening on stage.

As a theatre maker, you place a mask on the stage and BANG! You've transported your audience somewhere else.

The Freedom of Masks

For the theatre-maker and performer, the use of masks opens up a world of possibilities – an ensemble of four can suddenly play a number of characters without the audience recognising each actor by their face; a young actor, through detailed physical work, can play a 75 year-old woman; someone bored of being typecast as the beautiful ingénue can finally become the villain... The list goes on.

Mask can transport us to a land far, far away. Once we have signaled to the audience "we're not dealing with the real world here", we can take them on an epic journey, through rivers, mountains, busy cities – supported by good lighting and appropriate music, the mask can takes us anywhere without leaving the stage.

Safe behind the mask, the actor is likely to be freer to experience a range of emotions. Having to find a different way of working and being "shielded" from the audience by the mask can help to dive into areas we didn't dare to before.

In his book "Training for the Theatre", Michel Saint-Denis recalls how his uncle Jacques Copeau began to use masks in rehearsal. One of the actresses he was working with was holding up a rehearsal as she struggled to express her character's emotions in an appropriate physical manner. In an attempt to put an end to her self-consciousness, Copeau threw a handkerchief over her face and asked her to repeat the scene. Her body relaxed at once and she was able to play the scene. And so the mask was used as a training tool for the first time.

But of course this freedom comes at a price: the removal of facial expression and speech from performance.

The Discipline of the Mask

There are many rules to follow when using the mask and these can all be discovered by the student as they experience and observe what works and what doesn't. The first rule to be discovered is: when working with a full mask, you can't speak. When using a half-mask, you can't just use your own voice, you have to find a different one. Not any voice will do, you need to find the voice of the mask.

Whereas television focuses on the face, the mask directs the audience's focus to the body. So relying on facial expressions to convey emotion is no longer possible – which by the way, does not mean that an actor's face stays neutral when working behind the mask. On the contrary, as humans our faces are changed by emotion. The actor's face behind the mask should remain expressive, but the emotions will be channeled through the body.

Masks in Training and Education

The mask will take an audience into a different world and help the actor to connect with their body and find emotional truth.

These are aspects that should be part of all theatre experiences, regardless of the performance style. The mask can therefore highlight their importance and be very useful when training the performer or teaching drama.

The neutral mask in particular, is a wonderful teaching tool. It only comes alive when the actor is fully present and moving with economy. Those watching their fellow students can see what works and what doesn't. Furthermore, it is only through interaction with the rest of the class that the student can learn to use the mask, by gauging their reactions as an audience and receiving verbal feedback when the exercise is over. This process highlights the collaborative aspect of theatre-making and the importance of learning from watching others.

Neutrality, Selflessness and Economy of Movement

"Detached from your own face and words, both of which you can usually master in a social context, the body emerges as the only thing to guide you through the silence and you begin to feel its importance."

Jaques Lecoq, 'Theatre of Movement and Gesture'.

Wearing a neutral mask for the first time can have one of two effects (or both!): it can feel liberating to stand in front of an audience hiding behind a mask or it can be incredibly exposing as all you can

do is "be there", present, without entertaining an audience through the use of speech or acting tricks.

The neutral mask, expressionless, should help us find a state of neutrality, that "blank sheet" from which we can start to create. The mask highlights mannerisms and accentuates the posture. For those students or performers who have difficulty in connecting to the body, it might help them to alter their posture, to be aware of how they can adjust their stance.

Underneath the neutral mask, the face disappears and the audience takes in the whole body. A small gesture, a slight shift of body weight will become apparent... and important. Too much movement and the audience will just see an actor with a mask . However, make the right gesture and the audience will be moved.

It is important to ease the students slowly into mask work, to allow them to experience each exercise with masks. For some, it will only take a short time for them to express emotion, even to play a situation. Others will discover for the first time that it is possible to communicate without words.

Working in a mask requires both discipline and selflessness – great qualities to nurture in any performer and indeed, in any individual.

The Truth Behind the Mask

To the inexperienced performer, the mask might seem to be a piece of costume, something you put on your face that makes you look different. It's therefore very important to remind the students that the depth of work achieved by working in mask is similar to that of working without it. Assuming that working in a mask only involves wearing it is like assuming that in order to perform a script you just have to read the text. It won't work.

The emotions still need to be true. You still need to play a character. And you still need to communicate with your audience.

The essence of acting in a mask is the same as any other form of acting, you just need to shape your performance in a different way. Using everyday gestures when wearing a mask does not work – you have to find a new performance language. Trying to gesture to replace words does not work either. Any attempt at naturalism will cloud the mask.

Performing in a mask is not cosmetic, only emotional honesty will work. In order for the audience to believe that you are sad, you will need to find a place of sadness. Clouding the emotion with big gestures showing how you remove the tears from your eyes will not work – but an honest sigh which leads to a depression of the chest, might bring a tear to the audience's eyes.

The best work takes place when the performer is fully in character – when the actor is not thinking about what they will do next, they just do it; when they are not thinking: how would my character react? They just react. Similarly, performing with a mask requires this kind of commitment, losing oneself in one's character. For some performers, it might even be easier to make new discoveries behind the mask, where they might find it easier to "let go".

Building a Character

If you or your students are used to creating psychological profiles and back-stories for characters which then feed into the physical performance, then it might be useful to think of the process of working with a mask as the opposite of this.

When working with a mask, and in most physical theatre, the discoveries will be made in the space. To discover our masked character we don't need to think about it, we just wear the mask and remain open to what it suggests; to what our interaction with the audience suggests. Pretty much like with a character, we might not be sure of who this person is we are creating, but just get a sense for it. Then we can experiment with the physicality of the character; we can

feel what works best. We can interact with objects, maybe with another mask, with the audience... And following a period of exploration, we can then begin to decide on those aspects of the character that interest us most or that feel 'right'. From here we can build the psychological profile of the character and decide on their back story. We are building a character from the outside in. (The exercises 'Interactions' and 'Character Back-story' in Chapter 4 are particularly useful for this and can easily be adapted for mask work.)

Simplicity

One of the most challenging aspects of working with a mask is the simplicity required. The mask will only take one thought at a time. This is difficult for a contemporary performer, especially when used to dealing with subtext.

To say that a mask can only carry out a gesture at a time would be simplifying the process. What's required is clarity of thought.

CHAPTER 10

WORKING WITH MASKS

Here are some exercises to help you and your students get ready to work with masks. Depending on the age of the performers and the depth of the work, some will be more suitable than others. If you are only spending a couple of sessions on mask work, then a good physical stretch followed by an exercise like Grandmother's Footsteps might suffice to get into the spirit of the work. If you are working on masks over a term (or longer) or creating a performance, it is important that you spend about a quarter of the session warming up – this will help the students develop the physical awareness and focus needed for mask work.

A Word on Coaching the Mask

The role of the teacher or "mask coach" is essential to help performers develop their characters. You will need to "coach" the mask, to guide the performer through their thought processes by talking to their character.

Coaching requires detailed observation, focus and imagination, as it will help the performer develop their character in the early stages. Less experienced students will tend to stand in the space not doing

much. The mask needs to move in order to become alive and the character behind the mask should be developed primarily in the space – the role of the coach is central to this process.

To help the students build their characters, you will have to pick up on the smallest/subtlest of clues and body language. For example

Hello. Don't you want to step into the space? You like to maintain your distance? Are you observing us? Ah, I think you're making me a bit nervous.... You seem pleased. Maybe you like making people nervous.... I'm not nervous anymore, why don't you try with someone else? Yes, with them... Don't you like them?

By making suggestions they can react to, you take the pressure away from the student to create. They become less self-conscious as they are splitting the focus with you. They can make spontaneous decisions and movements.

Try to ask closed questions. Open-ended questions like "Why don't you like her?" might encourage the student to start gesticulating to express a thought or idea, taking them back into naturalism.

Devising with Masks

One of the beauties of creating a piece of theatre with masks is that the students can be easily encouraged to create through being in the space and watching others, rather than be tempted to sit down and write a script.

Working with masks provides the opportunity to create a new world with characters that interact in ways different to those in the "real world", where speech and facial expression are often the main tools of communication.

Central to the process is the role of the audience/creator. The performer working with the mask will have ideas to build on, but

hopefully, their spontaneity will also create new situations, movements and emotions. The audience is there to record these and to make suggestions about how they can develop.

Creating a Character in the Space

Following preparation, ask the Mask to enter the space. There might be a chair in the space. Or a table with a prop.

Welcome the mask.

Hello.

Wait for a response. Depending on the response, ask why they are feeling that way.

You seem a little shy. Are you scared of us? Maybe you just don't like meeting new people. If you're more comfortable maybe you can sit down on the chair. Go on... If you're worried it's dirty, just dust it off with your hand. Is it comfortable? I see from the way you are sitting on it, you are still a bit nervous about talking to us...

Try to pick up on movements, gestures or postures that might indicate a certain emotional state. You can also ask questions about family or background...

Did you get here on your own today? Was it a long journey? Are you tired? Really? How tired? That much? Do you make this journey often? You must be really fed up...

You can go on for as long as you want to or for as long as you think the performer can take it. It is important to let the students know

beforehand, that depending on what happens in the space, you will take longer with some students than with others and that this has to do with how relaxed the performer is and how suited they are to the mask.

(In medium-large groups, you might want to have two or three masks at the same time.)

After the exercise, ask the performer to take off the mask and tell the rest of the class about any images they saw, or about some of the reasons for their behaviour. For example, following the coaching to the mask above, you might want to ask where they were coming from and why they made that journey every day. After a couple of minutes, ask the audience for suggestions to develop the character they have seen. For example, how old do they think the character is, whether they have a family, what job they might be doing, etc.

If the group is small, it might be interesting to work with the same mask again, to develop some of the ideas. For example, the mask above can be going on a long journey every day because they take the train, the bus, the tube and then walk to their place of work every morning. You can then ask the performer to show us what that would be like; some of the other students can help by being other passengers, walls of the train, the seats, etc.

Further Development

This is also an opportunity to help the performer develop their physicality further, experimenting with different techniques (e.g. the Elements) or simply just by adjusting their posture or movement (e.g. take wider steps to make them prouder; soften the chest to make them humbler).

Following this, you might want to continue developing characters and story through the last two exercises in Chapter 4.

"Playing in Mask": Grandmother's Footsteps

When working with masks, Grandmother's Footsteps can also be used to train focus and body awareness. The face is always facing the front, no matter where we are moving, how we are moving, we always face the front as our focus is on grandmother. Spatial awareness becomes very important – I don't need to look at what my limbs are doing, I am SENSING how they move through the space.

Through this exercise the performer can also practice suspension. Suspension is very important for the mask performer – too much movement clouds the audience's perception of what's going on – characters have to give each other focus and every little movement might distract an audience. However, we can't just freeze, or stay still: we have to SUSPEND.

More specifically, Grandmother's Footsteps can also be used to develop the characters in the space spontaneously, to create pictures, ideas and relationships that can be used in a new piece.

Once the students are familiar with the game of Grandmother's Footsteps and they are used to working with masks, they can play the game wearing their masks. You can change stage 2 to create material or ideas for scenes between characters. For example, instead of placing 2 chairs in the space, you can place 3 (recognised symbol for the set sofa) and have the masks lie on it before they can touch Grandma – this might be helpful when building a scene taking place in the living room. Following this, you can add a remote control and make holding it once part of the rules.

Play the game with only five masks, or even three. Explain to your students that they will need to slow down a bit; that they will need to adapt to the mask and find a new way of playing the game. Ask them to let the mask affect how they play but avoid adding any "character or emotions" to the game or they will miss out on some genuine exploration. Avoid telling them in advance that you might also be

creating material for a scene, as they might begin to generate that material in their heads.

Masks are child-like and so the best way to start coaching the masks in this game is when Grandma first turns round. Some of the masks might be scared the first time this happens. Play with that.

What happened there? Did Grandma scare you? She's just playing a game with you. Come, come touch Grandma, you see, she doesn't bite... (To the other mask, who is laughing) You find it funny? Is that because she didn't scare you? Is that because you are older? You've seen it all before haven't you? (To the third mask, who hasn't moved one bit) Wow, look at you, holding that pose, well done... You're really good at this, aren't you? What other poses can you do? I think the next time Grandma turns round, you should try to do something that really shows your ability, like standing on one foot...

Just by playing the game and having Grandma turning once, three different characters have emerged: a naïve/childlike one, a streetwise one and a proud one.

Ask the audience to watch what is happening to the performer's bodies as they play the game, allowing the masks to take over. Every part of the body should be warm and loose and therefore ready to express a variety of emotions. Maybe the child-like character's arm is particularly expressive; or the actor playing "the proud one" is sticking out their chest; maybe the hips of the actor playing the "streetwise" one have become really loose...

Playing with the mask without worrying about performing, about technique, about creating a character or creating a scene, will make us use our bodies in the most appropriate ways. This is the exploration process: during it, we can make a note (best if our audience makes a note and then feeds back) of what it is that we are doing that rings true; of what is helping the audience through the illusion that the mask has come alive.

So, in the example above, the actor playing the streetwise kid might swing their hips; their weight might be further on their heels than their toes; they might bob their head when they nod. Ideally, the performer will not think of any of this when they work with their mask and the physicality will become just a part of playing the character. However, we are all human and sometimes it takes a while to get inspired. If, at some point in the class or in rehearsal, a performer has trouble getting into character, they can use these three key actions to help their body and minds remember the mask.

The Elements into Mask

You can use the Elements to develop the physicality of the mask characters.

Ask the students to pick one or two elements that are suitable for their characters or that they want to explore further. In small groups, give them some time in the space to explore the movement wearing the mask. Ask them to cross the space, sit down, pick up a chair, an object... Ask them not to worry about the audience, just to play in the space. After five minutes, ask them to make a decision on the element that suits their character best. For the more advanced students you can suggest they choose one element for the top half of the body and a different element for the bottom half.

Work with each student individually. Following coaching instructions similar to those in the exercise Creating a Character in the Space (described at the beginning of this chapter) ask the students to work with the physicality they have chosen. Make sure that they are embodying the element with every part of their body. After a while, suggest a different element for them to work with, to see what happens to their character.

PART 3
FIVE PLAYS TO PLAY WITH

"Words without thoughts, never to Heaven go."

Hamlet.

SO YOU WANT TO BE A PHYSICAL THEATRE PERFORMER?
by Pilar Orti

Introduction

Professor Phillipe Hoffmanonsky, from the LeyCoke Institute of Bodily Mimed Expressive Arts takes us through the characteristics of physical theatre and the qualities of the physical theatre performer. This brief "lecture" takes a comic look at physical theatre - the need for slow motion, non-linear structure and much, much repetition...

This is an Ensemble play which will require the performers to act as a chorus. It can be used as an introduction of how the chorus can be used in modern performance and I've included brief notes to explain some of the concepts in this "lecture".

Even though this piece is a satire, it can be used as an introduction to the devising process. Students might not be used to working together on their own for long periods and this exercise can help them to identify some of the difficulties they might encounter once they start working together without a teacher to supervise them.

Using So You Want to Be A Physical Theatre Performer?

If you have a small group, you can give them the lecture and ask them to stage it. With larger groups, they can work on different sections or they can all work on the text in different ways.

The students can address the following questions before or after they have played with the text. As with all exercises, it's important to analyse what worked and what didn't, raising the students' self-awareness about their own preferences. Here are some questions you can ask:

- Before they start working on the piece, how will they decide who does what?
- How will they make sure that everyone feels like they're involved in the process and in the play?
- How will they make the transitions from one part of the lecture to the other?
- How can they work as a chorus but also make sure that their characters are well defined?
- How bold can their choices be in defining their character's physicality?
- Is it important that the text is spoken by one person or can different actors take the role of the Professor? How will this work, how will the changes be smooth?
- Is music suitable? What about sound? Or maybe we don't need a soundtrack at all?
- How much does the chorus need to demonstrate and how much can we rely on the audience just listening to the Professor's words?

Elements of Physical Theatre Appearing in this Piece

The Ensemble

The ensemble is the group of actors in a piece, all of which have parts of more or less equal importance. While in Musical Theatre the ensemble is usually the chorus, in Physical Theatre, the ensemble tends to refer to the full cast.

There is emphasis on "ensemble work" during physical theatre, as importance is placed on the whole piece rather than individual stars or roles. This is of particular relevance if chorus work or configuration mime is used, as you will see later on in the lecture. A piece has an "ensemble feel" to it if all the actors seem to be working well together and being generous with each other.

The Chorus

The chorus is a group of people who move and/or speak as one or as if they were one entity. In some pieces of physical theatre you might see clumps of people moving together. The difference between a chorus and an ensemble, is that the actors in an ensemble can work independently of each other and have character parts. For example, the actors playing Romeo and Juliet can be part of an ensemble. Some of the cast from Romeo and Juliet (or all of them) will form the Chorus at the beginning of the play, an entity speaking the prologue.

The Clown

The physical theatre clown is different to that of the circus clown. Sometimes they wear a red nose but this is not necessary.

The physical theatre clown is a character who wants to please everyone (the audience, mainly) and will go to lengths to do so. "Can

you lift that wardrobe?" "Yes!" or "I've heard that you are really good at banging your head on the wall, will you show me?" "Yes!"

As you have gathered, the clown first says "Yes!", whether they should or not and then performs the action.

If they hear you laugh, they will do it again... and again... and again, for your pleasure.

The clown also moves and thinks with the Yes/No rhythm. They are never sure of where they are going. So they will always be late, always get on the wrong bus, end up in the wrong town... Yes, there are many people in real life who are natural clowns.

Surrealism

Physical theatre performers will use the body in ways that you wouldn't observe in real life. That's the beauty of it, you can go beyond realism.

Federico Garcia Lorca's 'Blood Wedding'

Of course the real title of this play is 'Blood Wedding', you wouldn't expect the Professor to get it right.

The poetry and style of this play allow it to be adapted for physical theatre. As it is, it has some wonderful scenes in Act 3 with characters such as the Moon and Death and a Chorus of Woodcutters.

If you don't mind not being precious with the play, you can also include other chorus scenes to highlight the tragic undertone throughout.

Configuration Mime

As opposed to the more popular object mime, when someone pretends to use an object that is not there, or stuck behind an imaginary wall, configuration mime involves performers taking on the

"role" of an object or part of an object. For example, as in the lecture, all performers can pretend to be the wall (as opposed to miming it). My favourite example is The Haunted House, where performers pretend to be all kinds of objects and furniture in a haunted house: a rug that roars when you step on it, a chair whose arms strangle you, etc.

SO YOU WANT TO BE A PHYSICAL THEATRE PERFORMER?

A lecture in seven freeze frames by Professor Phillipe Hoffmanonsky, from the LeyCoke Institute of Bodily Mimed Expressive Arts

by Pilar Orti

PROFESSOR
Good evening, and welcome to the first series of lectures delivered by Forbidden Theatre Company. Here to help me, are my visual aids, students of the LeyCoke Institute of Bodily Mimed Expressive Arts.
(The students remain motionless, expressionless, the extraordinary representation of NEUTRAL.)
This programme of BODILY lectures has been DEVISED in order to further our Education Programme. Tonight's PIECE addresses the question: why do so many young people in our current society want to be physical theatre performers?
It is important, first of all, to look at the origins of British physical theatre. How this complicated yet emotive art form came to be. Being

an horticultural society, it was only a matter of time before this branch of theatre prominent in Europe planted its first seeds in our country.

(Of course during this, the students "become" a tree growing.)

And now it is time to ask: what qualities should one look for in the physical theatre performer? The most important thing to remember is: that although there IS an "I" in Physical Theatre, (one in its written form, two in its spoken form, I being the "EE" in PHY and the "I" in SICAL, and of course there is another EE in THEatre, although this one is only spoken, not written) although there is an "I" in physical theatre, there is no "I" in ensemble, if not, it would be insimbil, or eenseembeel.

The physical theatre performer has no ego, he, or she, must give themselves entirely to his or her craft. Black rehearsal clothes are imperative, to form a true ensemble, where the whole is larger than the sum of its parts. Which neatly leads us to the Chorus.

(The students clump together, like a Greek chorus.)

Ah, the Chorus. It reacts, *(the students act surprised)* it moves as one *(the students move forward together, as one)* and yet, if you watch carefully, you can still see the individual characters coming through *(the students take on individual characters, waving at the audience).*

The physical theatre performer uses his body as his tool to create Character. The physical theatre performer does not waste his time thinking of the emotional makeup for their new persona. What's more important is how they move: how they walk, how they look, how they scratch their nose. All this allows for instant communication with the audience about the character's state of mind. There is no need therefore to find your character's "motivation" as long as you know its "movilization".

This question of a character's movement leads us neatly, (unusual for a physical theatre piece for there is very rarely a linear narrative and nothing leads neatly from one thing to another) to Running.

(The students run, on the spot of course, in true physical theatre style. They change their actions as the Professor mentions them.)

The physical theatre performer must be Oh-so-fit! They need to run, and jump, walk in different manners, run, and run and run, fall on the floor, bash themselves against the wall, hit themselves...

And they need to be able to do this at varying speeds.

(The students move in slow motion.)

Slow motion is a very important part of physical theatre. It serves to highlight those important moments which you want the audience to remember. It is a very useful device used by those who are, indeed, devising – unfortunately in this day and age, audiences expect a theatre event to be a certain length. Slow motion can be very handy when a company runs out of creative juices and need to, as it were, flesh up the show.

Then there is The Clown. But of course, Clowns are not part of proper physical theatre.

It is very important, in order to attract a young audience, that at some point in a physical theatre piece, the performers do, "a little dance", to a well-known contemporary track. In order to do this at your own will, and for no apparent reason, the description of your show has to have the word "surreal" in it. Or, should you want to explain to your audience the reason for it happening (which, I would like to reiterate is not always compulsory when working within this genre) I suggest, you say, it was "A DREAM"(mouthed)...

ENSEMBLE

A dream... a dream... a dream.... *(whispering and echoing, while moving around the space, in darkness.)*

PROFESSOR

Thank you. Repetition, Stylised language, especially delivered in a violent manner, is an integral part of physical theatre. To illustrate this, my students have prepared their own adaptation of Federico Garcia Lorca's Bloody Wedding.

GROOM

Mother

(ENSEMBLE as Echo: Mother mother mother.)

MOTHER (obviously symbolising death):

Yes?
GROOM
I'm going.
(Echo: Where? Where? Where?)

GROOM
To the vineyard.
(Shock from chorus.)
MOTHER
(under her breath, to the chorus) Not yet....
GROOM
Give me the knife.
(Shock from Chorus. Chorus break out into "The Knife" (different poses))
(They all freeze and a slow motion sequence follows where people kill each other and love each other in many different ways.)
BRIDE
There was no moon the night the poet died.
CHORUS
The moon... DEATH!
(One of the students comes in, holding a lit lamp.)
GROOM
Mother
I'm going.
To the vineyard.
GROOM
Give me the knife.
(GASP from the Chorus and THE END.)
PROFESSOR
 As you can see, the economy of language means that the author's ideas are conveyed in the most pungent manner, hitting the audience in their gut, before they have time to process what they are watching or hearing.

So, not to lose the purpose of this lecture. Why do so many young actors want to go into Physical Theatre? It is not a medium to further a showbiz career. Indeed I always ask my students to leave their ego outside the rehearsal room. The ego lingers around, tries to creep in, but never manages to make it back into the performer's body. Every time you work with a new ensemble, there is a need to develop a new physical language – company members must make sure they are talking the same talk, walking the same walk, miming the same wall. Or indeed, becoming the same wall.

If what you are interested in is developing emotional characters, with deep lives and lots of lines of text, physical theatre is not for you. Indeed, often you will find yourself becoming some inanimate object – your character, will not even have a name. Just "chair" or "section of wall number 1". Physical theatre performers will become large objects, like, a wall....

(The students become a wall and follow the Professor's list.)
PROFESSOR
Or a river, or an ocean....
Or a forest, which can engulf some poor passer by....
But they can also become smaller objects, like chairs, sofas, tables...
(As they become the different objects, the students start fighting, in slow motion of course, and making the accompanying sound effects.)
PROFESSOR

Hey, please, we have a lecture here to finish. Come on! Focus! Focus! Discipline!

(One of the students punches him, music kicks in. as the different students fall on the floor, the lights start dimming, until only the light from the lamp used by "The Moon" earlier is left.)

BLACKOUT

THE END

UP THE HILL BACKWARDS
by Richard Mann

Introduction

Charlie is a regular guy who falls in love with a regular girl. But getting the girl of your dreams is not always that easy, especially when your imagination leads you to imagine a murder attempt.

This is a purely visual play. There are only two sentences in the whole piece – everything else is told through action. An underscore can be used to give it the feel of a classic European film.

Written for four people, this piece requires the performers to abandon the need to use language to communicate and focus on developing the characters and their relationships.

Up the Hill Backwards was turned into a short film by Future Legend in 2004.

Using Up the Hill Backwards

We have evolved to use language to communicate with each other. Even though we are used to reading people who are in front of us or watching stories unfold in front of our eyes, we are now using words more than ever – through texting, through e-mails, through posts on the net.

So the first time you ask a student to communicate without using words, they will try to find a substitute for them. In their mind, they will still think that unless they use something to substitute every word, the audience won't understand them.

Imagine you ask someone to improvise, without using words, a scene in a bakery. It's likely that as the customer comes in, instead of lifting their eyes and smiling to greet them, they will wave at them vigorously, open their arms and pull a quizzing face, then point at the customer and then gesture towards their (invisible) fresh products. What the student really wants to do is say, "Hello, welcome to my store, what would you like, from my fresh range of products?" Instead of finding another way of communicating this, they try to find a gesture to substitute the words they can't use.

This script is a great tool to show students that we don't need to understand literally everything that is being said on stage. That we can strip down language to a minimum and tell the story through action. Even if the words we speak are in a made-up language, through intonation and how they're delivered, through what the characters are doing, the audience will follow the story. Even though we communicate mainly via words, we don't always need to understand what someone is saying to be interested. Sometimes, in our heads, we will hear the actor speak words we understand, even if they're in another language. Audiences have imaginations, let's find ways of taking advantage of this.

You can use this script as an introduction to how we can move a story forwards through action without dialogue. Read through the script with the whole class so that everyone is familiar with the story and then give each scene to a group.

There are sections in the script where it's easy to speak a made-up language than to perform them in silence. The piece, although stylised, is still set in ordinary places (a café, a cinema) and so it's easier to perform using some kind of speech. An easy way of getting around the block of "what is this made-up language" is to just say the word "walla" or change its vowel sounds. This is a better alternative to

the more popular "rhubarb" because its easier to string the words together.

Ask the students to stage the piece. Once you've watched all of them and talked through the process, ask them to devise a short scene in a similar style. (If the students are not used to working in this way, you might want to play some music underneath the scenes to avoid a self-conscious silence.)

Here are some of the questions you can ask both after the performance of the script and their own devising:

- How easy is it to perform without using words? Do you enjoy it? Why/why not?
- Does music help you in any way? How?
- What goes on in your mind when you're communicating without words?
- As an audience, is the story clear? Do you know what the characters are feeling?

UP THE HILL BACKWARDS
A physical piece of theatre for 4 actors, to music

by Richard Mann

CHARACTERS
The Guy
The Girl
The Friend
The Waiter
A Couple - made up of a Girl and a Bloke
Another Bloke

Scene 1.

The Café.

The Girl walks in. Looks around. Finds a table, sits down. The Waiter takes her order.

The Friend enters, looks around, sees The Girl. She goes to her table, they embrace each other, then sit down at the table.

The Waiter is serving, calling out to chef and constantly brings drinks and food out.

The waiter carries a large knife, which he uses to cut up pizza, bread etc.

The girls are chatting and laughing loudly. The scene is very busy.

The Guy walks in and crosses the stage, the girls and waiter look at him. He turns round and they all look away. He crosses back to the other side, yet again they all look at him, he turns round, they look away. He crosses once again, this time when he looks around The Girl is staring at him, a moment.

She beckons him over, then writes out her number on a piece of paper, she hands it to him then gestures him to phone her. Happily he nods and walks off, only to realise he's going the wrong way. He turns to see the two girls and waiter looking at him, fumbles and exits off the other side. Lights down.

Scene 2.

The Mirror.

The Girl walks into the toilets, looks around for anyone else, then satisfied, she goes over to the mirror (in front of audience), places her

bag down on table, opens it and starts to apply make-up in an over the top fashion.

The Friend enters and The Girl cranes her head to look at her. They stand facing each other, tilting their heads from left to right checking each other out.

The Girl circles The Friend in a bitchy way. Then there is stand off, with The Friend being first to draw. Suspense Western style.

Both then apply make-up in an over the top frantic way. When finished there is a beat. Then both embrace each other, lots of laughter and oooo's and Ahhhh's. Both then go over to mirror; with The Friend opening a slightly larger bag. There is a subtle look from both as she is opening her bag and then when The Girl opens her smaller bag. Both put on make up. Once they are ready,they all exit together.

Lights down.

Scene 3.

The Cinema.

A row in a cinema. The film has already started. A Girl and a Bloke come in and take their seats. The Guy and The Girl come in, having to squeeze past the other two. The focus is very much on their first date.

All sit facing forward as if looking at the screen. Girl looks at The Guy then at her boyfriend (The Bloke) who swaps seat with her.

Audience reactions; something funny, then even funnier, then scary (The Guy reacts really over the top by jumping onto the chair), the other couple react to him.

Bloke on stage right of The Guy farts, reactions of suppressed laughter from that couple, then looks of disgust from them and The Girl towards The Guy. The Bloke then puts his arms around his girlfriend and The Guy. Looks from The Guy and The Girl, then look

to Bloke who reluctantly takes his arm away (wondering what the problem was).

The Guy stares at the girl lovingly (puppy eyes); she gives him a 'what are you doing?' look. He then puts his hand on her leg. Beat, she places it back. Subtly he tries to put his arm round her shoulder, stretching arms forward, then up, then knocking her head side wards.

He gets up from seat apologising to her, falls backwards onto bloke's lap, who pushes him off. Ends up on his hands and knees in front of the girl, a look. Travels backward out of the seating, apologising to everyone as they are all looking at him. Lights down.

Scene 4.

The Dejection

The guy walks away from cinema, downtrodden, he trips over something, a look. Stops centre stage and posture falls with an out-breath. Walks to bench, dusts off mess on it, sits down, puts hand on chewing gum. A Mosquito buzz's, The Guy follows it with his eyes, claps at it mid-air, it stops. It starts to rain, he puts his hood up.

A Bloke comes along, sheltering from the rain and sits beside him, a look. Stops raining, they both pull their hoods down, a look. Music stops.
GUY:
Women!
BLOKE:
Don't you just want to kill them sometimes!
Music resumes. Both of them get up, the Bloke walks off. The Guy looks forward seriously thinking about what the Bloke said, he closes his eyes...

Scene 5.

The Dream.

The Guy imagines that he is with The Girl, she walks on, stands by the side of him and places her head onto his shoulders. He goes to touch her head. Headwaiter comes on and takes her hand and pulls her away. She has disappeared and when he looks up he can see the waiter with the large knife, above her head, leering at him. He rubs his eyes and when he opens them they have both disappeared.

The Guy walks away, downtrodden, he trips over something, a look.

Lights down.

Scene 6.

The Café.

Repeat of the first scene. The Guy is standing at the side furtively looking at all the action from behind a newspaper.

The Girl and The Friend have arrived, they are sitting at their table. The Waiter is about to serve them pizza.

The Guy, remembering his dream, thinks that the Waiter is going to try to kill The Girl. Music stops. He lunges at The Waiter in slow motion, screaming at him in a battle cry way 'AAHHHHH!', to stop him. He tackles him to the ground. They roll over with a deep 'Thud', sounded by The Guy.

Then he makes a heart beat noise.

There is a pause as the girls all look in shock at The Guy. The Waiter is confused and dazed. The Guy gets up realising his mistak. The Waiter lunges for him and starts shouting and chasing him. Music and action resume.

The Guy runs round the back of the chairs, circling them. As he passes the girls one of them joins in chasing. The second time around the other girl joins in. They all run off.
Lights down.

BLACKOUT

 THE END

CAIRO 1948
by Phillip Johnson and Pilar Orti

Introduction

A short two-hander. Part film noir, part melodrama, 'Cairo 1948' is the story of a man and a woman who fall in love only to discover they are both on different sides of the law.

'Cairo 1948' is set in a bar in Cairo, a jeep in the desert, another bar in Nairobi and the jungle in Thailand. And it spans two decades. Quite a challenge for two performers.

Using Cairo 1948

This play is a prime example of melodrama. Well, melodrama mixed with a bit of clowning and a bit of storytelling. So I suppose it would be better to say that the acting in this piece will be more akin to that you expect in a melodrama than in a naturalistic piece, how else can you get away with lines like "Take me out of here, take me away from it all!"

This piece presents many challenges for the performers:

- The characters are also the narrators. The actor doesn't break from their character to become the narrator but needs to stay in character in the scene while also telling the story.

- The piece has a bit of action, including a death. It takes place in two locations you would associate more with film than theatre: first we're in a café full of soldiers, Casablanca-style. Then we move to the jungle, in Thailand.

- The piece is obviously not taking itself too seriously. And there lies the greatest challenge of them all. We need to find a style where we can make the ridiculous lines sound truthful, build our characters and create a strong relationship between the two protagonists. If we don't believe the characters, the piece just becomes a bad sketch.

CAIRO 1948
by Phillip Johnson and Pilar Orti

Scene 1

MAN
Cairo 1948. The war was just over. I was in a bar. Drinking. On my own. And then I saw her. There she was, standing, next to her mike. Singing.
(The damsel sings.)
MAN
I watched her sing. She could really sing.
When she ends her singing:
MAN
Would you like a drink?
WOMAN
Yes.
MAN
That's a lovely singing voice.
WOMAN
Thank you.
MAN
Would you like another drink?
WOMAN
Yes.

MAN
Time passed.
WOMAN
Take me out of here. Take me away from all this. The routine. The singing. Take me away from it all.
MAN
So I did. The next day we set off on a journey. In my jeep. But when we got to the frontier.... Oh no. The guards. We can't go there.
WOMAN
Why not?
MAN
I... I never told you what I did for a living.
WOMAN
Does that matter. Is it relevant to our.... Love?
MAN
I.... I smuggle illegal arms. To the rebels.
WOMAN
No!
MAN
She battled with her thoughts. Half of her wanted to stay with me. The other half.... Didn't. She stepped out of the jeep.
MAN
Where are you going? Get back here. You'll never survive out there in this heat.
WOMAN
The soldiers can protect me!
MAN
From that day on, I knew I could never again look her in the eye.

Scene 2

MAN
Nairobi. 1968. The smuggling industry was on the decline. With better customs, the African countries were doing the smuggling themselves. I went to a bar. And there she was. Singing. Oh how she could sing. She was singing about us. Around her, the tables were full of soldiers. I could see by the way they were looking at her, that she'd been around.
WOMAN
Then I saw him. He was looking at me in... that way he had of looking at me. What I wanted to do was...
(She throws herself into his arms.)
WOMAN
Oh darling! I have been waiting for you to come back. I know that what you do is not very noble but.... Oh teach me how to smuggle! Teach me how to traffic in arms! *(They waltz.)*
WOMAN
But all I did was....
(She continues singing.)
MAN
I couldn't look her in the eye.

Scene 3

WOMAN
Thailand. 1970. The Guerrillas were about to knock out the current government. It was hot. I was wearing my camouflage gear and was carrying two rifles, in each hand. And then in the distance... I thought I saw someone I recognised.
Is that...? It all came flashing back. I was in that bar again. Singing... And he was back at the bar... offering me a drink... But the reality wasn't as glamorous. I was in the middle of the jungle fighting for survival. The guerrillas needed their arms and I was there to provide them.

MAN
The government was looking for the rebels. I had left my smuggling job and was now employed by the CIA to look for those who were illegally defying the state. And then.... And then I saw her. Carrying two rifles... in each hand. It all became clear, when I was reading the brief, the profile of the leader of this smuggling ring, I couldn't get her out of my head... and now I knew why.

WOMAN
You...

MAN
I.... Am...

WOMAN
I'm sorry...

MAN
I'm sorry too... and in the middle of all this, gunfire... the rebels approaching... A stray bullet... And her... Dying in my arms..........

(They dance the waltz.)

BLACKOUT.

THE END

LEGACY IN BLOOD
by Mark Reid

Introduction

Written mainly as a monologue, 'Legacy in Blood' begins with a dark ritual, where a woman is offered as a sacrifice to the revered... Mark. An unlikely person to be worshipped, Mark tells us the story of how he discovered he was, how shall we put it, not quite human.

This piece requires a performer who can show the character's vulnerability as well as his darker force.

Using Legacy in Blood

It might seem a bit strange to include a monologue in a book mainly dedicated to physical theatre. However, playing with this text can help the students with traditional storytelling, where the actor is connecting directly with an audience. It's also a good exercise for learning to judge when stillness is the best option and when to demonstrate action.

The piece also presents an interesting challenge: the speech is contemporary, as is the setting (he has a fridge at home) but there is a classical and remote feel to the piece: it begins with a scene at the

altar, a sacrifice, and the main character is a vampire. It's a good example of how surreal and real elements can be mixed, as well as how classical and modern styles can blend.

The text can be used to inspire a story. If this were the stimulus, how could it be developed into a piece? What characters are in the story? What scenes could be created from the events narrated? What style would be more appropriate? What would be more fun? How could we turn a piece which is mainly a monologue into an ensemble piece?

LEGACY IN BLOOD
by Mark Reid

(The High Priest enters the stage mumbling an incantation. Off stage a discordant chorus sings. As High Priest stands downstage facing thr audience, the singing stops. Two people enter from upstage wings. One carries a black book, the other a knife. They take up position behind High Priest and hand him the items. High Priest opens the book, holds the knife and recites.)
(Music.)
HIGH PRIEST
Guardians of the East, whose element is air: blow away the veil that separates us from the world of darkness. We summon you to witness our rites and to guard the circle.
(High Priest moves clockwise to the side of the stage and is followed by the duo.)
Guardians of the South whose element is fire: who forges passion and desire in your flames, we summon you to witness our rites and to guard the circle.
(The group moves upstage.)
Guardians of the West whose element is water: out of whose depths life dwells eternally, we summon you to witness our rites and to guard the circle.
(Group moves stage left.)
Guardians of the North whose element is earth: by seed, root, stem and bud, bring us to stand on thy hill of vision. We summon you to witness our rites and to guard our circle.

(Having cast the circle, High Priest takes centre stage holding the knife. He is flanked either side by his two acolytes. Acolyte 1 moves to the side of the stage and opens a door. Human Sacrifice enters in a trance and kneels before High Priest.)

Child of Darksome and divine,
Here we are to call ye forth!
We offer this sacrifice to you,
O prince of death and resurrection.
May this be the day of you sinful re-birth,
As we baptise you with the sweet eternity of life's legacy.
Pass among the shades and shadow of the night.
Move unseen among your enemies by day.
Come to us, your children, who accept you,
As if you were our own blood.

(High Priest cuts Human Sacrifice's throat. The acolytes pull red ribbon from the neck of the victim as the body slumps to the floor.)
(Music finishes.)
Pause.
(The door slowly opens and Mark crawls out rather un-elegantly. He stands before the worshipers, looking at each one, they leave. Mark walks down stage. He appears uncomfortable in the limelight.)

MARK

I've not always been this popular!

(Acolyte 1 and Acolyte 2 come back on stage to remove the body.)

MARK

In fact for most of my life I've not been popular at all. I've always found it difficult to make friends; I was a bit of a loner at school. I remember being jealous of the other kids at school whose parents read them bedtime stories at night. My parents never did that for me. I used to think it was because they didn't like me. But now I think they were just frightened of me. I think it was hard for them, not just because of me, but... they never really loved each other.

In 1983, I was 13! *A beat.* 1983 was a frozen summer. It sits in my mind, crystal clear, as if carved in ice. The emotions that separated

my parents are as real to me today as they were then. That summer, when my parents hearts froze. *A beat.* And silence. I really learnt the meaning of silence then. It ruptured from beneath our living room carpet. The carpet was white, shag pile and smelt like eucalyptus fabric softener, and when I was little I'd roll around on it pretending I was on the back of a giant sheep. I would look up into an imaginary sky and watch flocks of galahs and cockatoos dart and swoop like wayward firecrackers. That year the carpet lost its warm embrace. The fibres froze and turned to snow.

It was worse at night, the silence I mean. My parents sat in separate lounge chairs either side of it. A huge, invisible wall of silence. When it got bored of them it drifted down the hallway to find me. I could never concentrate on my homework; all I could hear was the screaming silence. It smelt fusty like the old photographs we kept in a shoebox in the attic. *A beat.* I told Father Shane, my school chaplain about it. He said I was just discovering that my parents were 'human'. *A beat.* I don't think he was right. I think it was probably the pair of other woman's knickers my mother found in the back seat of our car.

(Mark shuffles his feet on the floor. He looks as if he has run out of things to say.)

MARK

It was soon after that summer that mum told me I was adopted. It sounds weird, but I totally accepted it. I think I was relieved! I mean the idea of adoption wasn't completely alien to me. Giorgio, the foreign exchange student in my class, who once picked me for his side in footy; he was adopted! And we sponsored a girl in Africa, Sahwila. We used to keep a picture of her on our fridge. She had a swollen belly like a brown balloon, skeleton arms and the longest, softest eyelashes I had ever seen. She drew us a picture of a donkey once. Anyway, that was kind of like adoption. *A beat.* And my sister had a cabbage patch kid.

It was on a Thursday evening, she told me. We'd had torrential storms and smell of damp earth clung to the air. I'd just finished watching 'Buck Rogers' when mum came into my room.

I'll always remember the way mum told me. She used to be in her college debating team, so she had a way with words: 'That lazy, lying, cheating shit I'm married to isn't your father.'

And then she told me about my father, my REAL FATHER!

My real father wasn't the assistant manager of an electronics store. My father lived in the darkness of the night. My real father WAS the night. He was a powerful warrior who commanded an army of loyal men into bloody battle. He ruled over a kingdom whose people trembled at his very name. And if anyone said anything against him or teased him, them he ordered his army into the woods to chop down all the trees. They'd chop off all the branches and remove the bark. Them he'd grab his enemy and after greasing the spiked trunk with his spit, he'd stick it up their bottom, then out their mouth. And he'd put it in his front garden as a warning.

And my dad had special powers! He had command of the animals. He could talk to wolves. Make spiders do his bidding. And cats were his messengers!

But when you're that powerful, that special, people are jealous. And one day they're going to catch up with you. My dad knew he needed a son to carry on his legacy.

Then my mother whispered, as if she were drunk on the very word she was speaking. She whispered my father's name! And she had the most beautiful smile, one I'd never seen before.

As I heard his name my stomach turned inside out with dread and in my mind's eye, his face leered from the shadows. I heard my blood bubble up into my ears, I jumped off my bed and ran outside! I heard it before. My dad was famous. I'd seen films about him, read comic books about him; I even had a doll of him! I felt powerful, invincible. I jumped on the trampoline. (*Mark re-lives the moment.*) I looked up into the sky, and the night had changed. It was no longer a black lid sealing me into the world; confining me to this family, which suffocated me with their silence. I was free. *A beat.* The night sky glittered suddenly!

(*Music.*)

(Acolyte 2 enters the stage; she is manipulating a belt, perhaps like a snake. It slithers over to Mark, up his leg, and fastens itself onto his waist. A dinner shirt is manipulated by High Priest and Acolyte 1, some kind of monster! Mark and the shirt fight, during the battle the shirt is dressed onto Mark. Finally a black cape flies onto the stage, it envelops Mark, and fastens itself onto him.

As Acolyte 1 goes to leave after putting on the cape, Mark hypnotises her. She goes towards him willingly. Mark cradles her, and then takes a lunge towards her neck. Stopping short, he remembers something. Reaching into his pocket he takes out a pair of plastic 'dress up' fangs, puts them in his mouth, then sinks them into her neck. The woman faints/dies.

Music ends.)

MARK

My father so loved the world, that he gave his only begotten son, that whosoever believeth in him should not perish, but have ever lasting life.

(The woman turns her head towards the audience, her eyes 'snap' open.)

MARK

I am the son of Dracula!

BLACKOUT.

THE END

SOFTLY, SOFTLY
by Pilar Orti

Introduction

This allegorical piece is set in a small village, where there is a strong community feeling. Until one day the villagers loose the ability to speak. The disappearance of the voice brings the breakdown of all communication between the villagers and joy disappears from everyday life.

'Softly, Softly' is an Ensemble piece with seven (+1) characters (the +1 character only appears for a few minutes although his/her role is pivotal).

The piece uses repetition and a voiceover to give it a parable/fairy tale feeling and the actors are required to use the space in an imaginative way to create the atmosphere of a busy market. Mime is also required.

Using Softly, Softly

When we talk of choreographed movement, many students think we refer to dancing. (Even sometimes, when we talk about teaching "movement" it's mistaken for "dance". Sigh...)

Choreography is the action script, the set movements which help to tell the story in the same way as words do. Through choreographing movement, you can guide the audience's eye to where you want them. You can also help to set the mood or highlight an aspect of a character or scene.

In 'Softly, Softly', the scenes follow a movement/action template. The stall for the market is set up, the girls come in, and old couple interacts with an artist. We see this once. Then it gets repeated. Then we see it once again. And then... it breaks. Something happens. The audience, like the characters, has got used to the "routine", to a set way of seeing life in this village. And by breaking this, by changing the choreography, by changing its tempo or the execution of the movements, we invite the audience into the characters' emotional world.

This is a great way of introducing students to the discipline that you require as an actor. Many young people get bored of rehearsing. (It's not just young people, I worked with an actor once who changed his lines after a few performances because he was bored.) Going over a scene again and again and again can become boring if you don't understand the difference between a polished and a non-polished performance. This is a specific example of when everyone has to co-ordinate their moves and speech and repeat it with precision, or else the piece falls apart. The other challenge is of course, to keep everything fresh within that perfection.

'Softly, Softly' is an example of an Ensemble piece. A play where everyone has room to develop their own character while still being part of a defined group – the villagers. It shows how voiceover and repetition can be used to show the audience that time has passed. It shows how we can be economical with our language and how to stylise it. From a technical point of view, it also shows how you can incorporate a movement sequence into a script.

SOFTLY, SOFTLY
by Pilar Orti

Prologue

VOICEOVER
Once upon a time, in a land far, far away, there was a little village. Its market was a vibrant place, the site where everyone greeted each other in the mornings, the place where they all reminded themselves of how close a community they were.
(Music starts.)

Scene 1

(ALEX, the stall owner, and PAULA, his new assistant, come in, setting up two tables in the market.)
ALEX
This table goes here. This other one, there. Now the crates. Apples. Bananas.
PAULA
Apples, bananas. (Practising) You'd like an apple? Apples. Bananas.
ALEX

And here we have the Pears and Plums.
(He goes off to get the scale.)
PAULA
Apples, bananas, pears and plums.
ALEX
(*coming in on the last beat of the list.*) Scale.
PAULA
Apples, bananas, pears, plums, scale.
ALEX
Good.
(GEORGE, the artist, enters.)
GEORGE
Good morning!
ALEX
Lovely Day!
GEORGE
(to PAULA) Good morning?
PAULA
Hi!
ALEX
Your usual...
GEORGE
Apple.
ALEX
(As he picks up an apple and throws it to him.) Apple.
GEORGE
Thanks! (He sets up his drawing.)
(SIVE, a young girl, comes in.)
SIVE
Good morning!
ALEX
Lovely Day!
ALEX (to PAULA)
And we keep the cash here...

(PRISCILLA, another girl comes in.)

PRISCILLA
Good morning!
ALEX
Lovely Day!
(The girls start skipping. ALEX continues explaining to PAULA how everything works.)
(ERICA and MARK enter. They are an elderly couple.)
ERICA
Good morning!
MARK
Good morning!
ALEX
Lovely day!
(MARK and ERICA walk towards GEORGE and place themselves to each side of him.)
ERICA (to GEORGE)
And what are you drawing today?
GEORGE
Well, see this shape here...
(He is interrupted by:)
ALEX
Ladies and gentlemen...
(All look at Alex, frozen in expectation.)
ALEX
The market is now open!
(They all rush to the market)
GEORGE
(As Erica walks to the stall.) Get me an apple will you love?
(A choreographed sequence starts, where Alex and Paula serve the rest of the villagers.)
(The people are served, the girls leave.)
MARK

Come on dear.
ERICA (to GEORGE):
Here's your apple...
GEORGE
Thank you love!
(PAULA and ALEX start to pack up, GEORGE leaves. ALEX stops in the middle of the space.)
ALEX
Now that really was a lovely day!
(Lights down.)

Scene 2

A new day.

(ALEX and PAULA set up the stall.)
PAULA
Apples, bananas, pears and plums. Scale.
(GEORGE enters)
GEORGE
Good morning!
ALEX
Lovely Day!
PAULA
Hi!
ALEX
Your usual...
GEORGE
Banana.
ALEX
(As he picks a banana and throws it at him.) Banana.
GEORGE
Thanks! *(He sets up his drawing.)*

(SIVE comes in.)
SIVE
Good morning!
ALEX
Lovely Day!
PAULA
Hi!
PRISCILLA *(coming in)*
Good morning!
ALEX
Lovely Day!
PAULA
Hi!
(The girls start skipping.)
ERICA
Good morning!
MARK
Good morning!
ALEX
Lovely day!
PAULA
Hi!
(MARK and ERICA walk towards GEORGE and place themselves to each side of him.)
ERICA *(to GEORGE)*
And what are you drawing today?
GEORGE
Well, see this shape here...
(He is interrupted by:)
ALEX
Ladies and gentlemen...
(They all look at Alex, frozen in expectation.)
ALEX
The market is now open!

(As Erica walks to the stall:)
GEORGE
Get me an apple will you love?
(The people are served, the girls leave.)
MARK
Come on dear.
ERICA (to GEORGE):
Here's your apple...
GEORGE:
Thank you love!
(PAULA and ALEX start to pack up, GEORGE leaves.)
ALEX's last line is:
Now that really was a lovely day!

(Lights down.)

Scene 3

A new day.

(ALEX and PAULA set up the stall.)
PAULA
Apples, bananas, pears and plums. Scale.
(GEORGE enters)
GEORGE
Good morning!
ALEX
Lovely Day!
PAULA
Hi!
ALEX

Your usual...
GEORGE
Plum.
ALEX
(As he picks up a plum and throws it to him.) Plum.
GEORGE
Thanks! (He sets up his drawing.)
(SIVE comes in.)
SIVE
Good morning!
ALEX
Lovely Day!
PAULA
Hi!
PRISCILLA
(As she enters.) Good morning!
ALEX
Lovely Day!
PAULA
Hi!
(The girls start skipping.)
ERICA
Good morning!
MARK
Good morning!
ALEX
Lovely day!
PAULA
Hi!
(MARK and ERICA walk towards GEORGE. Mark SR, Erica SL.)
ERICA (to GEORGE)
And what are you drawing today?
GEORGE
Well, see this shape here...

(He is interrupted by:)
ALEX
Ladies and gentlemen...
(They all look at Alex, freeze in expectation.)
ALEX
The mar....
(His voice goes. He hasn't really realised he didn't speak, only notices that people are looking at him funny. He "says" again: the market is now open.)
(Everyone looks at each other. No one says a word.)
PAULA
Apples? Bananas? Pears? Plums?
(Realising that ALEX is not going to say his usual words, they follow the assistant's cue, and begin their usual routine. The buying actions are repeated, with a little bit of weariness as something is not quite right and they don't know how to treat Alex.)
(As Erica walks to the stall:)
GEORGE
Get me an apple will you love?
(The people are served, the girls leave.)
MARK
Come on dear.
ERICA (to GEORGE)
Here's your apple...
GEORGE
Thank you love!
(PAULA and ALEX start to pack up, GEORGE leaves.)
(ALEX and PAULA stop where Alex would have said, "That really was a lovely day". He starts mouthing "That really was...." And stops.)
(They leave.)

Scene 4

(ALEX and PAULA set up the market.)
(GEORGE comes in.)
GEORGE
Good morning!
PAULA:
Hi!
(ALEX gestures Hi!, makes a gesture which says, your usual?)
(GEORGE is not quite sure how to react.)
(ALEX throws him a pear.)
GEORGE (to PAULA)
Tell him thanks.
PAULA
Thanks.
ALEX (mouths, with no voice)
I can hear.
(SIVE comes in.)
SIVE
Good morning!
PAULA
Hi!
(ALEX gestures "Hi".)
PRISCILLA
Good mor.....
(Her voice goes)
(She repeats "Good morning!" Cheerfully as if nothing had happened, but no sound comes out. Wanting to ignore what's happened, she starts skipping (kind of) and joins Sive.)
(ERICA and MARK enter.)
ERICA
Good morning!

MARK

Good mor....!

(His voice goes.)

(He tries again.)

(ERICA starts the routine again.)

ERICA

Good morning!

MARK

(Mouths good morning, but nothing comes out......)

PAULA

Apples, bananas, pe....

(She too loses her voice and mouths "...and plums". She tries again, Apples etc, nothing comes out.)

(All half frozen, not sure what to do.)

(MARK and ERICA walk towards GEORGE. MARK SR, ERICA SL.)

ERICA (to GEORGE)

And what are you drawing today?

GEORGE

Well, see this shape here...

ERICA

Yes...

SIVE (joining them)

Yes....

GEORGE

It's meant to be a curve but at the end it goes into a sharp line

ERICA

Yes...

SIVE

Yes....

GEORGE

But here, where the blue is...

(He waits, thinking that Erica has lost her voice, but she just doesn't know that she is meant to say "yes".)

ERICA

Yes...
SIVE
Y...
(Loses her voice as before she says yes...)
(They all look at SIVE who looks terrified...)
GEORGE
(Hesitant) Well, the blue becomes green and the yellow becomes red and....
ERICA
Carry on dear, I find it all very interesting, I was once an artist myself you know, I used to...
(She loses her voice.)
(GEORGE gets up, terrified, as everyone can't speak except him.)
GEORGE
And when the red becomes white then you really get an image, a floor picture as we call it...
(He loses his voice, only he carries on as though he can still be heard. It's quite disturbing.)
(GEORGE leaves.)
(They all start to leave, one by one.)
(Lights down.)

Scene 5

VOICE OVER
Soon no one in the village had a voice. Time passed.......

(An attempt to repeat the usual sequence. ALEX and PAULA set up. GEORGE comes in. Kind of says "Hi". ALEX gets the fruit ready but as he goes to throw it to GEORGE, GEORGE has already turned round and is about to get to work. The fruit falls on the floor. The girls come in. The old couple comes in. ERICA goes to GEORGE, but MARK stays near the stall. ALEX goes round telling everyone

individually that the store is open – first he goes to the girls, then ERICA and GEORGE. MARK tries to get PAULA's attention. MARK is almost knocked over by ALEX as he returns to the stall. As the bump happens, everyone else gets stuck in their movement, repeating a short sequence.

MARK wants an apple, he gestures to ALEX, etc. Finally ALEX gives him the fruit. MARK pays ALEX.

The girls confuse PAULA, she puts some fruit in the bag and gives it to PRISCILLA.

ERICA walks around GEORGE and asks him if he wants a fruit. She walks to the stall. As she gets to the stall, the focus goes to the girls and PAULA.

PAULA finishes handing over fruit to PRISCILLA, puts fruit in another bag for SIVE and begins to do her sums. (MARK is leaving)The girls run away. PAULA about to tell them how much, she tries to shout after them.

ERICA about to pay. PAULA gestures to ALEX that the girls have left, he tries to shout but can't (!), then runs after them. ERICA confused. ALEX comes back. Him and PAULA upset. ERICA confused, leaves without paying, leaves without giving GEORGE his fruit. ALEX leaves, GEORGE upset without food. Goes up to PAULA, she shrugs and GEORGE takes an apple. Exeunt.

Lights down.)

Scene 6

(MARK and ERICA enter. ALEX enters. They look at each other – they are thinking about what to say. They lower their eyes. Cross over.

SIVE enters, PAULA enters with her crates, Priscilla enters, the criss-crossing continues.

At one point they are all in the space. They repeat a small movement, continuously, as if they were stuck in their own little routine.

PAULA walks by with the crates. SIVE tries to call out, can't, follows her. ERICA follows SIVE, PRISCILLA finds bank note that Erica dropped, shouts at her, decides to keep it, leaves the other way.
ALEX and MARK in a diagonal, lift their gaze, locked, begin to walk towards each other, not quite sure what to say, what to do.
A TOURIST enters, with a map
They all freeze and look at him/her.)

TOURIST
Excuse me, I'm about to run out of petrol, my car's just there and I'm trying to follow this map, where do I need to turn to get here?
(ALEX and MARK look at each other.)
TOURIST
I'm sorry to inconvenience you...
(ALEX and MARK half smile. They look at GEORGE, at each other and complicitly walk with GEORGE, guiding him to where he needs to go. The previous sequence where everyone ignored each other takes place again, only this time they begin to make eye contact with each other and interact.)
Through their interaction, they begin to feel like a community again. They guide The Tourist off stage.
To music.)

BLACKOUT.

THE END

FURTHER READING

Through the Body
by Dymphna Callery
A good overview of what is going on in the contemporary world of UK physical theatre. A lovely mixture of practical games and exercises, theory, reflection and some history. A whole chapter on Devising too!

The Mask Handbook
by Toby Wilsher
Written by one of the founders of Trestle Theatre Company, this book covers everything you need to know to create your own mask play. From mask making, through technique and tips on creating your own piece.

The Space to Move: Essentials of Movement Training
by Christian Darley
A beautiful book written by a practitioner completely in love with her subject and her students.
Full of anecdotes and exercises used in actor training that will be useful for anyone interested in how to remain connected to the body in performance. A great advocate for giving us all the space to create.

For more on devising and physical theatre, visit http://devisingandphysicaltheatre.com

ACKNOWLEDGEMENTS

Thanks go to everyone who, at some point, believed in the strength of the Ensemble at Forbidden, especially to Mark Reid and Richard Mann (contributors to this book), Steve Brownlie, Ruth Hutchinson, Tracey Hammill, Alex Perkins, Pilar Garces, Linda Baker (vital to the company's survival) and of course, Phillip Johnson, without whom Forbidden would have never existed.

ABOUT THE AUTHOR

Pilar wrote her first play when she was 7.

She got her friends together, rehearsed it and showed it to the rest of the class. It was such a good experience that she continued doing that throughout her time at school.

At the age of 10, she gave her first drama workshop, to a class of five-year olds. This was also a good experience, but she didn't get the chance to do it often. However, once she had trained as an actress, she felt like she had a bit more to offer than when she was ten, and so she gave it another try. Her first workshop went well, she loved it and she decided to do some more.

When you love every aspect of creating theatre, it's difficult to build a career. The best way to do is to run your own theatre company. At Forbidden, Pilar directed, acted, wrote, produced and taught. She was responsible for some dodgy experiments but she also managed to create some very special work. Eventually, the energy created by the Ensemble dissipated and so Pilar moved on, to another industry. Instead of promoting collaboration through creating theatre, she helps people in virtual teams to come closer together. If you're interested in this, you can follow her on Twitter, @PilarOrti.

If you would like to read some of Pilar's books, you can find them on Amazon. Just search for Pilar Orti. Feel free to connect via Twitter @DevisingTheatre or through www.devisingandphysicaltheatre.com

www.ingramcontent.com/pod-product-compliance
Lightning Source LLC
Chambersburg PA
CBHW021950170526
45157CB00003B/931